LEARN TO DRAW
CARTOONS

DRAWING
WITH *Christopher Hart*

LEARN TO DRAW
CARTOONS

The World's Easiest Cartooning Book Ever!

Get Creative 6

New York

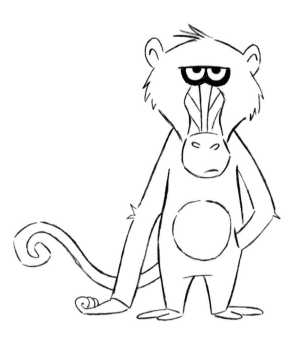

DRAWING WITH Christopher Hart

An imprint of **Get Creative 6**
104 West 27th Street
Third Floor
New York, NY 10001
sixthandspringbooks.com

Managing Editor
LAURA COOKE

Senior Editor
MICHELLE BREDESON

Art Director
IRENE LEDWITH

———————————————

Chief Executive Officer
CAROLINE KILMER

President
ART JOINNIDES

Chairman
JAY STEIN

Names: Hart, Christopher, 1957- author.
Title: Learn to draw cartoons : the world's easiest cartooning book ever! / Christopher Hart.
Description: First edition. | New York, NY : Drawing with Christopher Hart, an imprint of Get Creative 6, 2019. | Includes index.
Identifiers: LCCN 2019017180 | ISBN 9781640210509 (pbk.)
Subjects: LCSH: Cartooning--Technique.
Classification: LCC NC1320 .H354 2019 | DDC 741.5/1--dc23
LC record available at https://lccn.loc.gov/2019017180

Caution: This book is intended for use by adults. If children are permitted to use this book, be sure to provide them with child-safe supplies.

Manufactured in China

7 9 10 8 6

First Edition

*To Maria, Isabella,
and Francesca*

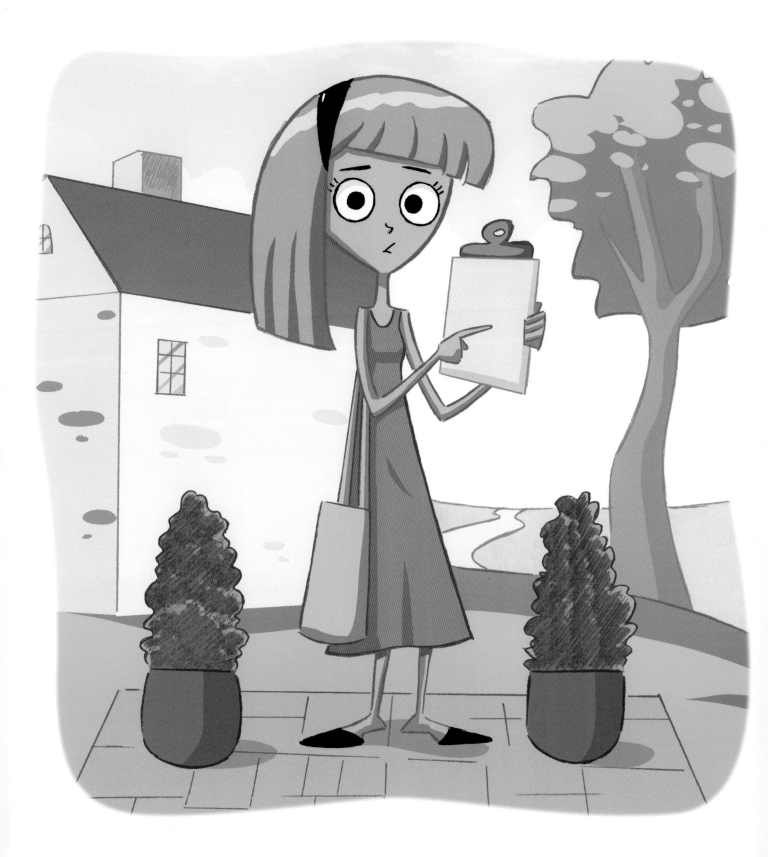

Contents

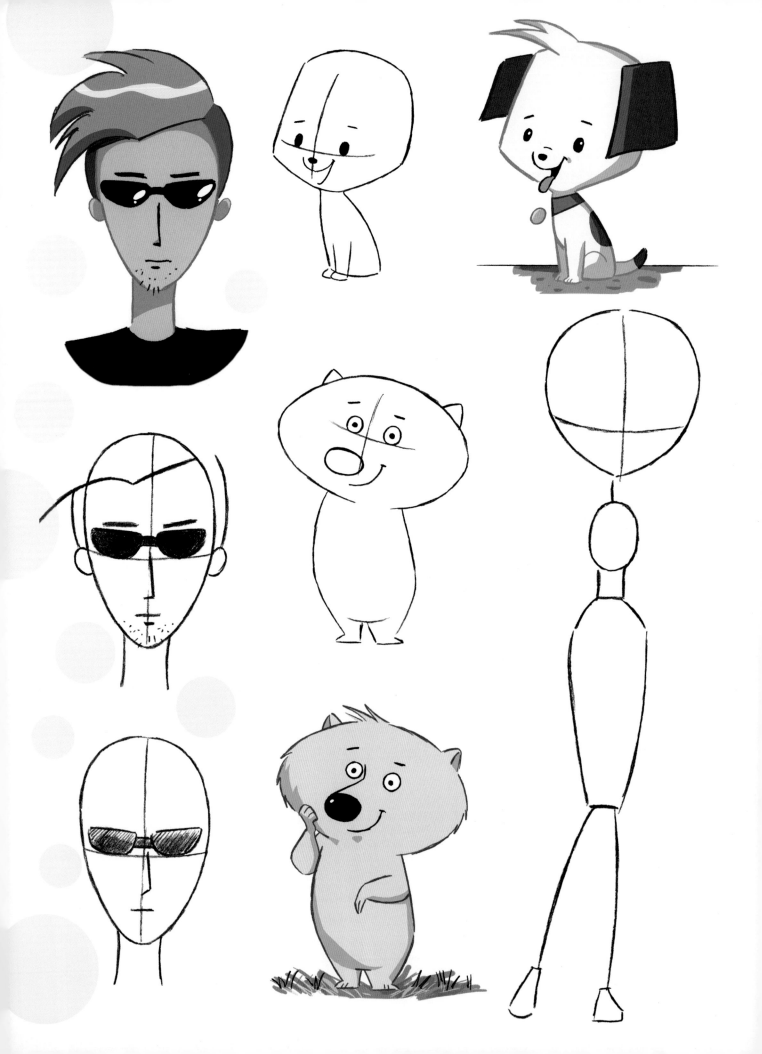

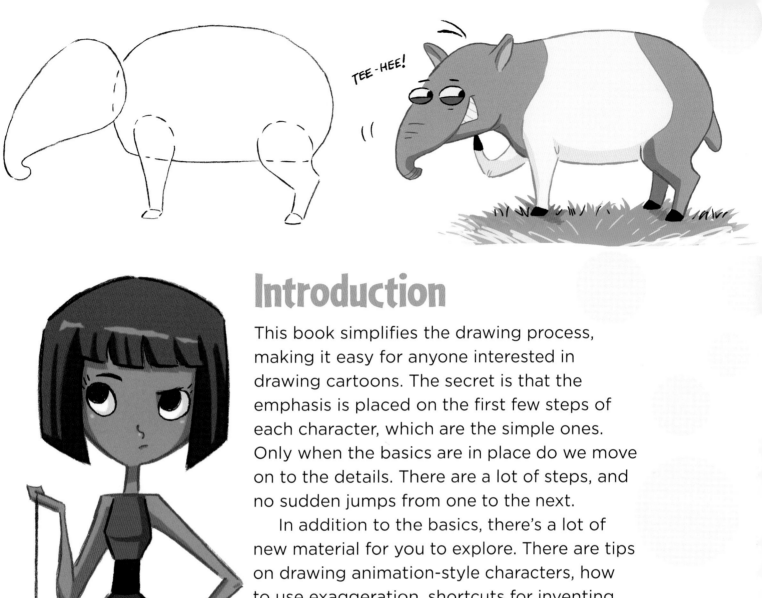

TEE-HEE!

Introduction

This book simplifies the drawing process, making it easy for anyone interested in drawing cartoons. The secret is that the emphasis is placed on the first few steps of each character, which are the simple ones. Only when the basics are in place do we move on to the details. There are a lot of steps, and no sudden jumps from one to the next.

In addition to the basics, there's a lot of new material for you to explore. There are tips on drawing animation-style characters, how to use exaggeration, shortcuts for inventing new characters and drawing funny outfits, and instruction on drawing quirky animals. All that's left is for us to begin!

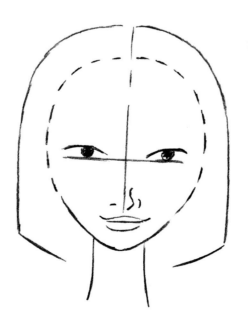
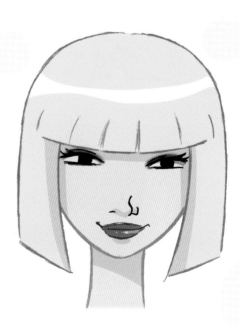

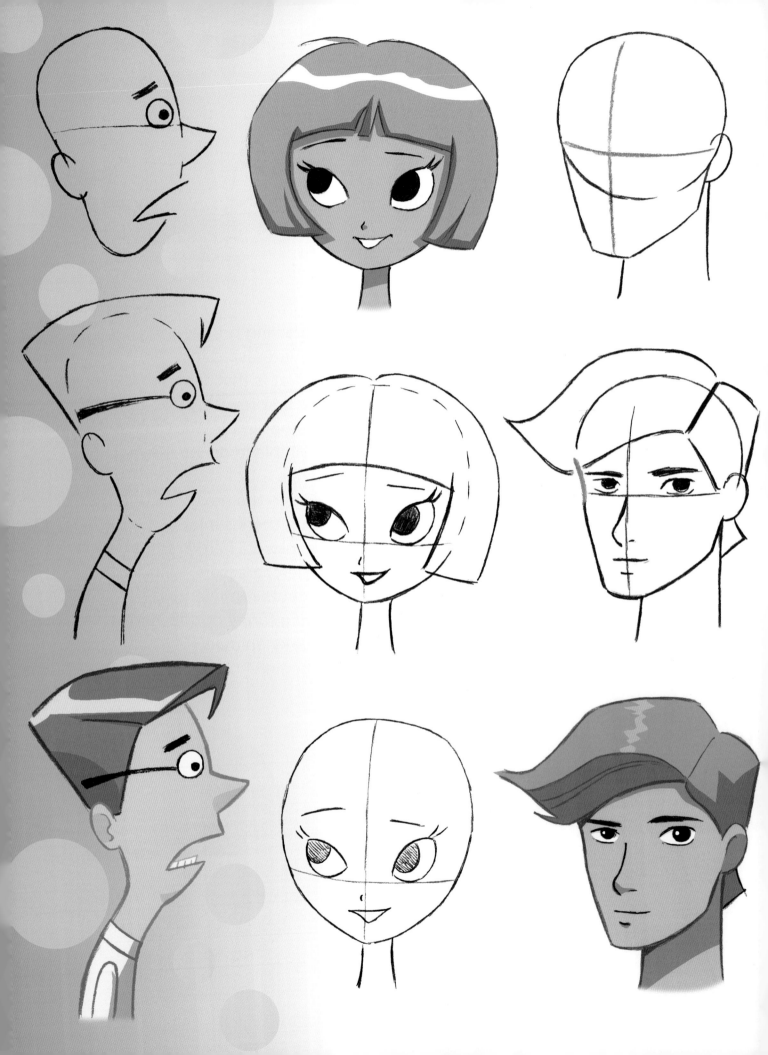

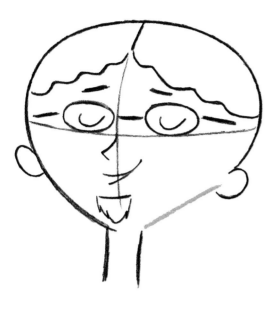

Simplifying the Cartoon Head

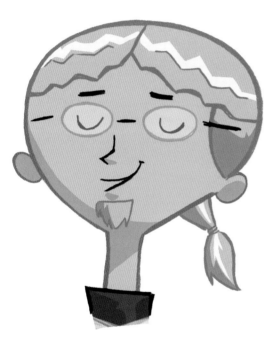

The most important part of drawing the head is keeping it basic in the first few steps. Save the details until you have first established the overall shape. It's fun to draw the eyes and hairstyle. But if you can stick with the basic construction for a step or two longer, you'll make fewer mistakes, and the details you draw will be much improved.

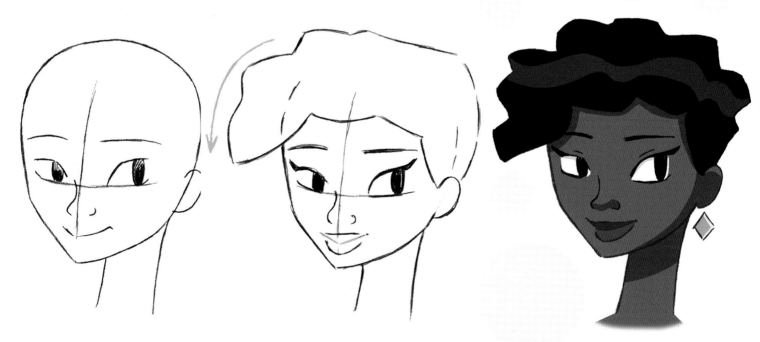

It's Simple Once You Know the Key

Look at the finished examples of the guy and gal characters. They look somewhat advanced, don't they? You might be thinking, "I'll never be able to draw those." But if you take a closer look, you'll see that the basic construction of the head is simple. Suddenly they look easy to draw. Throughout this book, the foundation of the head—and the foundation of the body—will always remain simple.

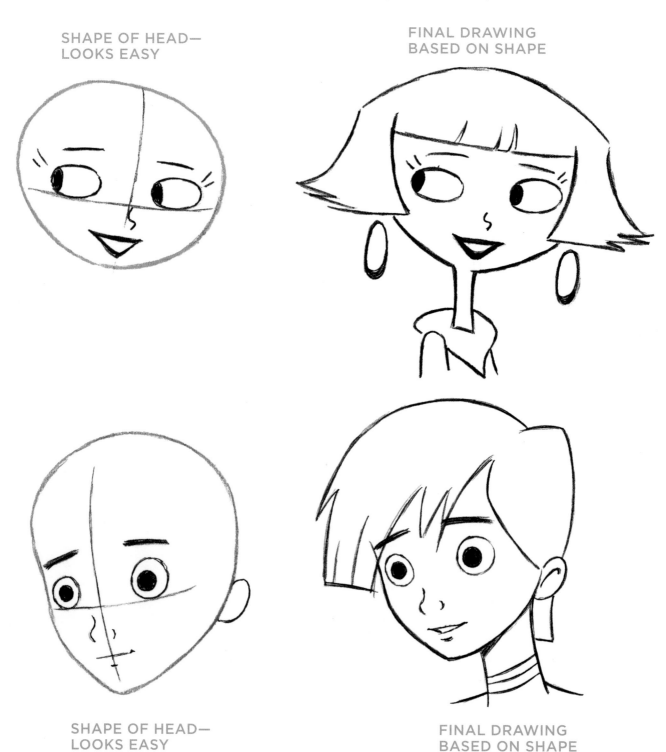

SHAPE OF HEAD— LOOKS EASY

FINAL DRAWING BASED ON SHAPE

SHAPE OF HEAD— LOOKS EASY

FINAL DRAWING BASED ON SHAPE

Let's Start with an Easy One

Most people start with the details and finish up by drawing the outline of the face. We're going to turn that order around. Instead of focusing on the details, let's focus on the construction of the head and the general placement of the features. Approached in this way, you'll build a solid foundation.

Start with a simple foundation for the head.

Work on the placement of the features. Keep them basic. You can refine them later.

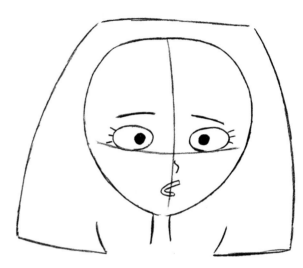

Draw the outline of the hairstyle. See how little detail there is? We don't need it yet, and we're already three steps into the process.

Short, choppy lines across the forehead to simulate bangs

The eyelashes are straight and short.

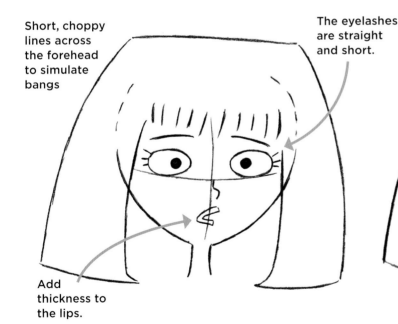

Add thickness to the lips.

Add the finishing touches (sunglasses, earrings) once everything is in place.

Simple Does It!

Even though this head construction is similar to the one on page 13, the character looks completely different. This tells you that you don't have to create a zillion different head types in order to create original characters. Instead, change the eyes, expression, and the hair.

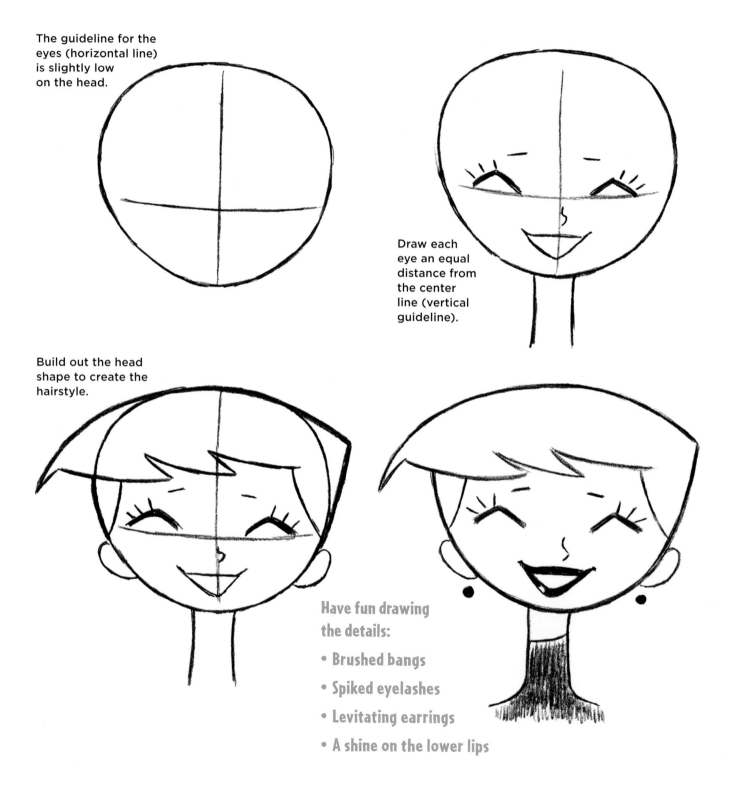

The guideline for the eyes (horizontal line) is slightly low on the head.

Draw each eye an equal distance from the center line (vertical guideline).

Build out the head shape to create the hairstyle.

Have fun drawing the details:

• Brushed bangs

• Spiked eyelashes

• Levitating earrings

• A shine on the lower lips

Turning the Head

When the head turns, it loses its symmetrical look. The back of the head straightens out while and the front of the face appears round. Sounds complicated, until we realize that we're only talking about two words: *straight* and *round.* Hey, we can handle that!

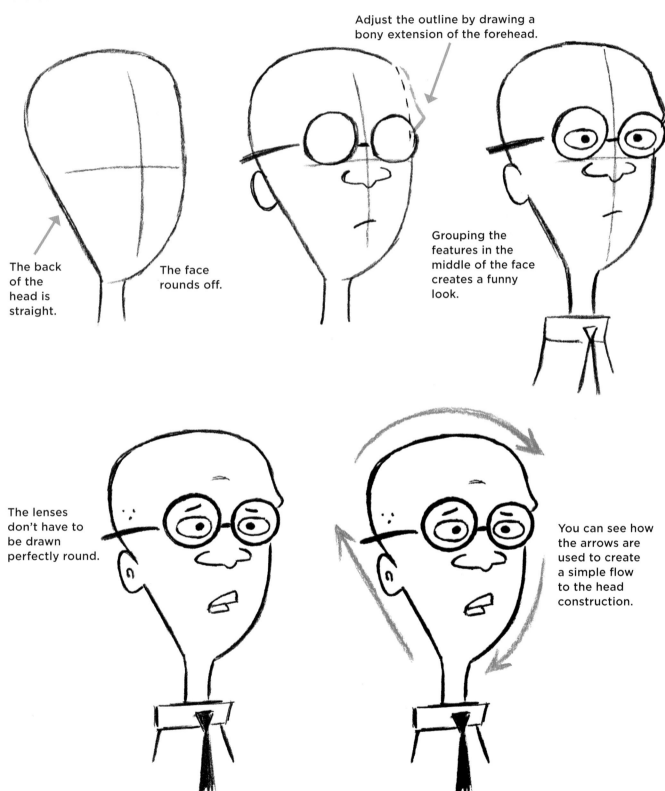

Adjust the outline by drawing a bony extension of the forehead.

The back of the head is straight.

The face rounds off.

Grouping the features in the middle of the face creates a funny look.

The lenses don't have to be drawn perfectly round.

You can see how the arrows are used to create a simple flow to the head construction.

Turning that Head a Little More...

When the head is turned even further—all the way to the right or to the left, the shape of the head changes again—into the shape of a jellybean.

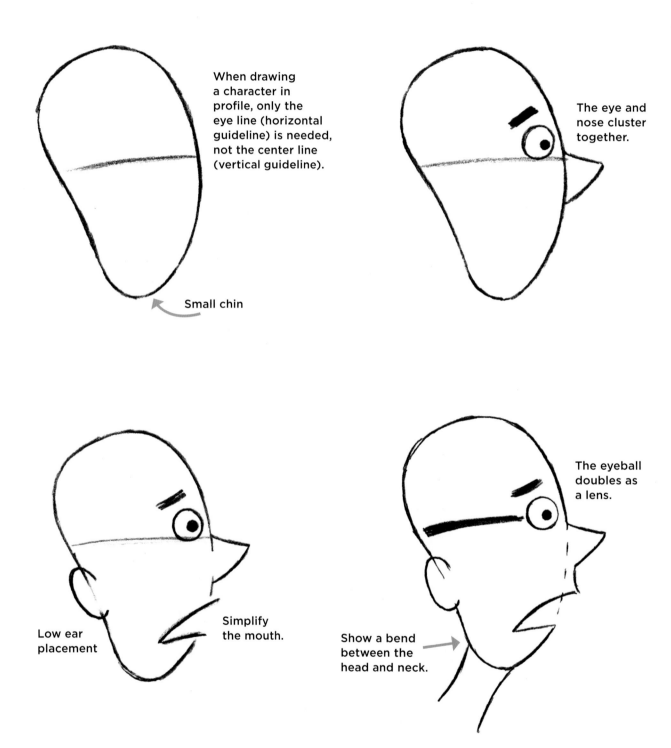

When drawing a character in profile, only the eye line (horizontal guideline) is needed, not the center line (vertical guideline).

Small chin

The eye and nose cluster together.

Low ear placement

Simplify the mouth.

The eyeball doubles as a lens.

Show a bend between the head and neck.

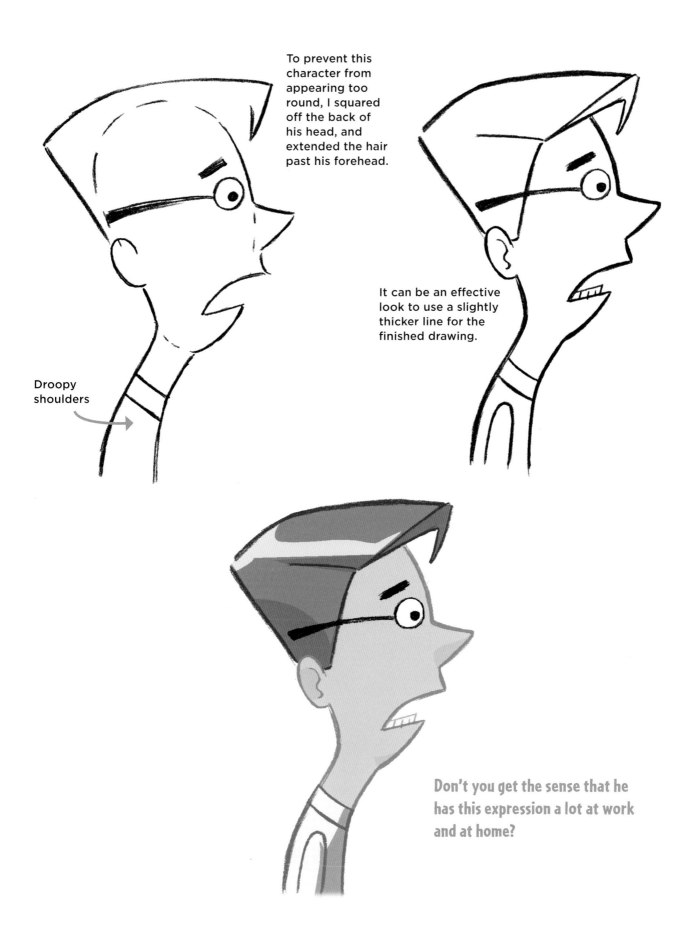

To prevent this character from appearing too round, I squared off the back of his head, and extended the hair past his forehead.

It can be an effective look to use a slightly thicker line for the finished drawing.

Droopy shoulders

Don't you get the sense that he has this expression a lot at work and at home?

Simplifying a Complicated Head Shape

When drawing a more challenging head, we can still simplify it. Begin with a simple sphere and gradually build the face around it. This makes it easy to get started.

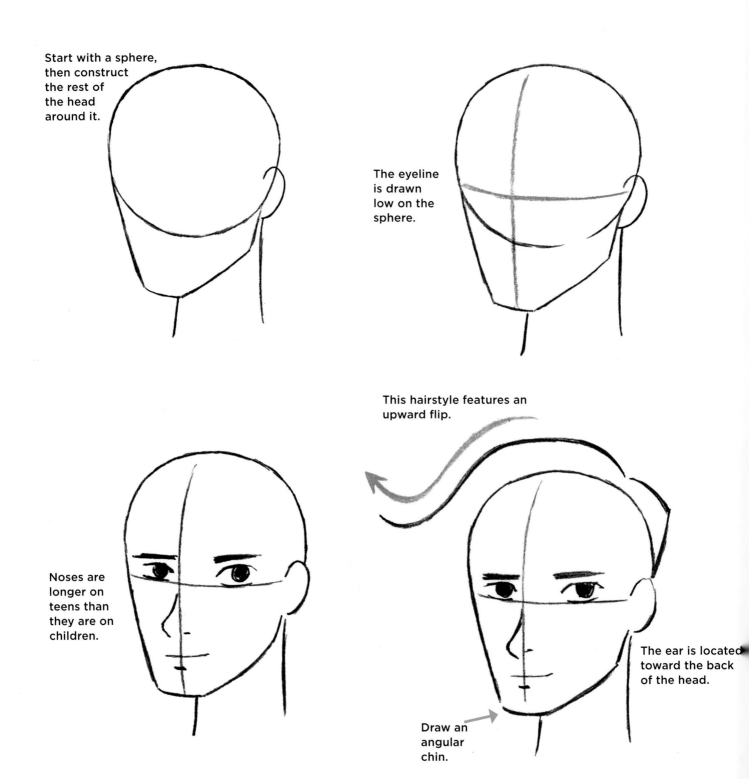

Start with a sphere, then construct the rest of the head around it.

The eyeline is drawn low on the sphere.

This hairstyle features an upward flip.

Noses are longer on teens than they are on children.

The ear is located toward the back of the head.

Draw an angular chin.

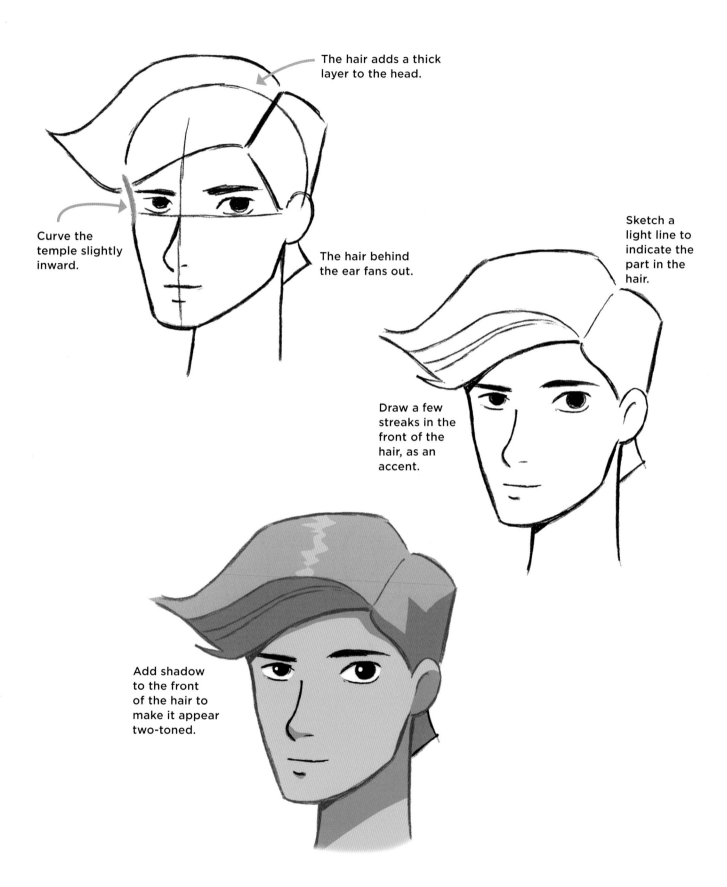

The hair adds a thick layer to the head.

Curve the temple slightly inward.

The hair behind the ear fans out.

Sketch a light line to indicate the part in the hair.

Draw a few streaks in the front of the hair, as an accent.

Add shadow to the front of the hair to make it appear two-toned.

Creating a Center of Interest

An excellent way to make your characters stand out is to create a center of interest. These centers are created by adding prominent elements, such as facial hair, glasses, and sunglasses.

Unshaven Chin

Placing the stubble in one spot (the chin) gives it more emphasis than if it were spread out. It takes up almost no space, but it stands out.

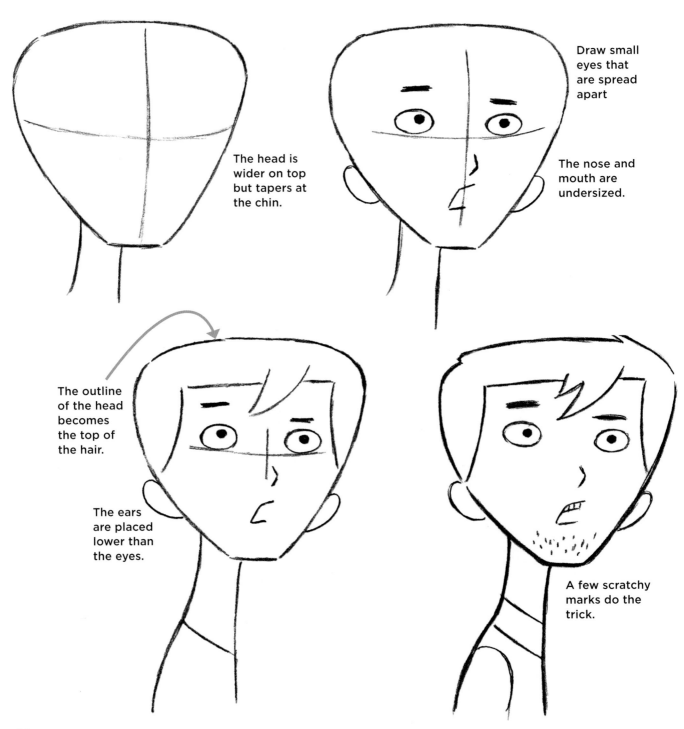

The head is wider on top but tapers at the chin.

Draw small eyes that are spread apart

The nose and mouth are undersized.

The outline of the head becomes the top of the hair.

The ears are placed lower than the eyes.

A few scratchy marks do the trick.

The Goatee

A full beard can take over the look of a character. A goatee, on the other hand, adds a humorous accent to the image.

The head is flat on top, then widens to a full face.

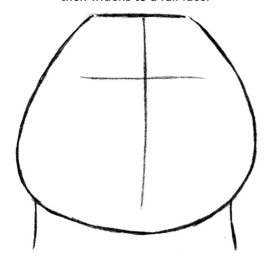

Cluster the features toward the top of the head.

Tiny ears are a funny touch.

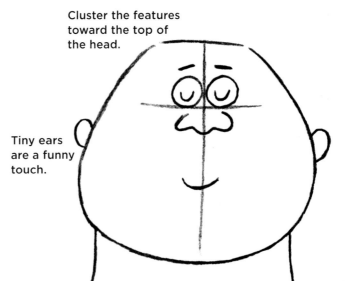

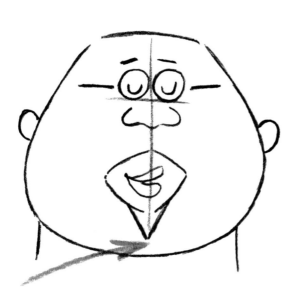

Leave space between the tip of the goatee and the bottom of the face.

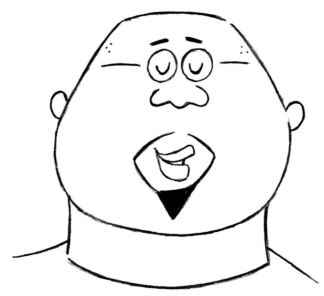

Don't crowd the mouth area with the goatee. Give it some breathing room.

College Professor Hairstyle

This is the stereotypical anti-establishment college professor. They all conform to this look. Rather than get a haircut, he ties it into a ponytail. The beard is a lip patch rather than a true goatee (not a winning look on a dating app). The glasses give him an intellectual look.

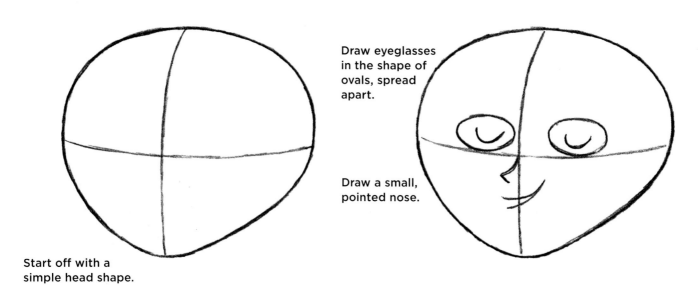

Start off with a simple head shape.

Draw eyeglasses in the shape of ovals, spread apart.

Draw a small, pointed nose.

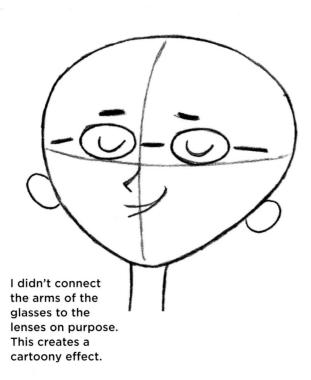

I didn't connect the arms of the glasses to the lenses on purpose. This creates a cartoony effect.

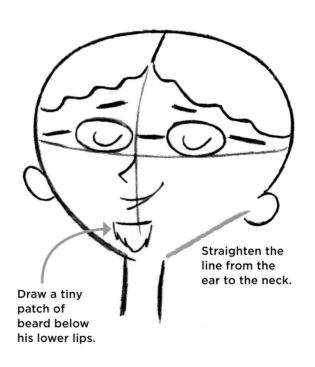

Draw a tiny patch of beard below his lower lips.

Straighten the line from the ear to the neck.

COLOR NOTE

You could add a blue tint to the glasses to make them seem reflective. Alternatively, you could use a flesh color to indicate that they're transparent.

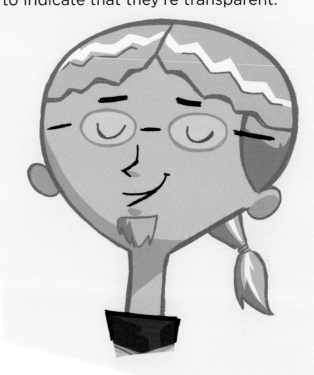

The wavy hair, ponytail, and lip patch tie the style together.

GLASSES: YES OR NO?

Do glasses add to the look of a character? Or do they complicate the drawing? This is a matter of personal taste, but I think glasses are generally a good addition to a character's design.

NO GLASSES WITH GLASSES

Sunglasses (and Whiskers!)

How are you supposed to create a personality for a character if you can't see his eyes? By enhancing the rest of the character's appearance. Combining the sunglasses with whiskers and a dramatic haircut will do the trick.

Start with a balanced, basic construction of the head.

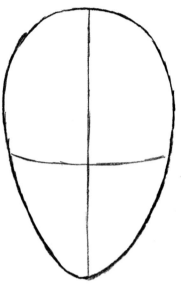

We'll go with medium-size lenses. You can choose any size.

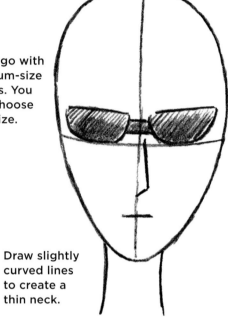

Draw slightly curved lines to create a thin neck.

Build out the hair on both sides of the head.

The eyebrows are drawn above the sunglasses, not inside of them.

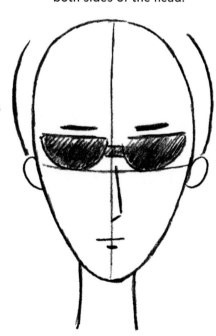

Swing the hair over to the side for style.

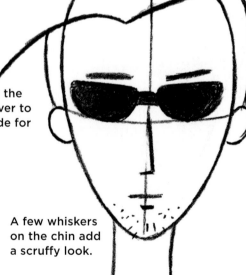

A few whiskers on the chin add a scruffy look.

Draw shaggy ruffles of hair, brushed to one side.

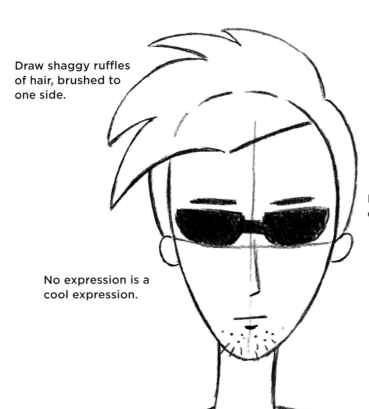

Leave off the arms of the sunglasses.

No expression is a cool expression.

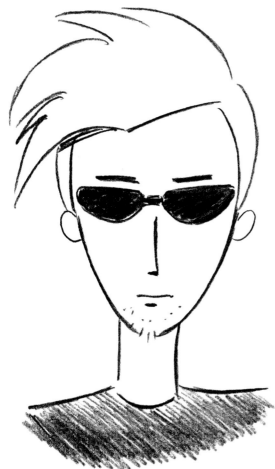

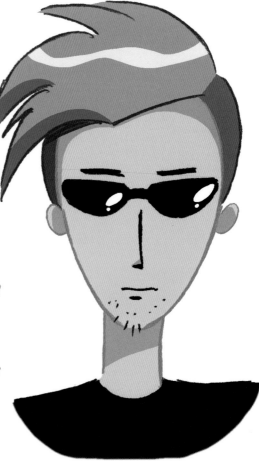

Self-check your sketch:

- Are the eyebrows evenly aligned?
- Are the sunglasses evenly drawn or tilted?
- Check to see that the nose is long and thin.
- Choose a dark color for the shirt to tie it into the dark sunglasses.

Drawing Attractive Characters

Just as funny and cute characters are essential types, so are attractive characters. Don't be intimidated by the hairstyles or the number of eyelashes you see. The key to drawing pretty characters is to begin with a simplified head construction.

Oversized Eyes

The eyes of a character should sparkle but they need a little help to get that way. By drawing them disproportionately large, you create an area of interest that attracts the reader. Focus on the overall shape of the eyes. For example, these are tapered at both ends.

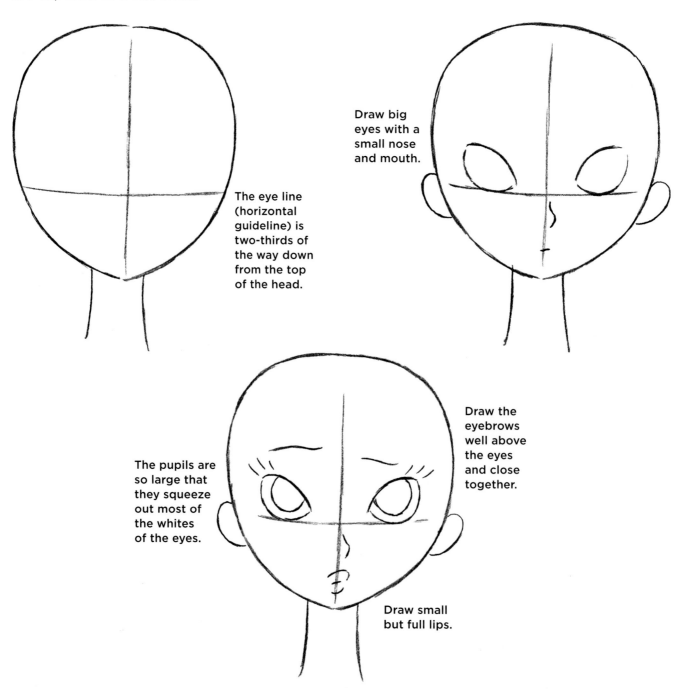

The eye line (horizontal guideline) is two-thirds of the way down from the top of the head.

Draw big eyes with a small nose and mouth.

The pupils are so large that they squeeze out most of the whites of the eyes.

Draw the eyebrows well above the eyes and close together.

Draw small but full lips.

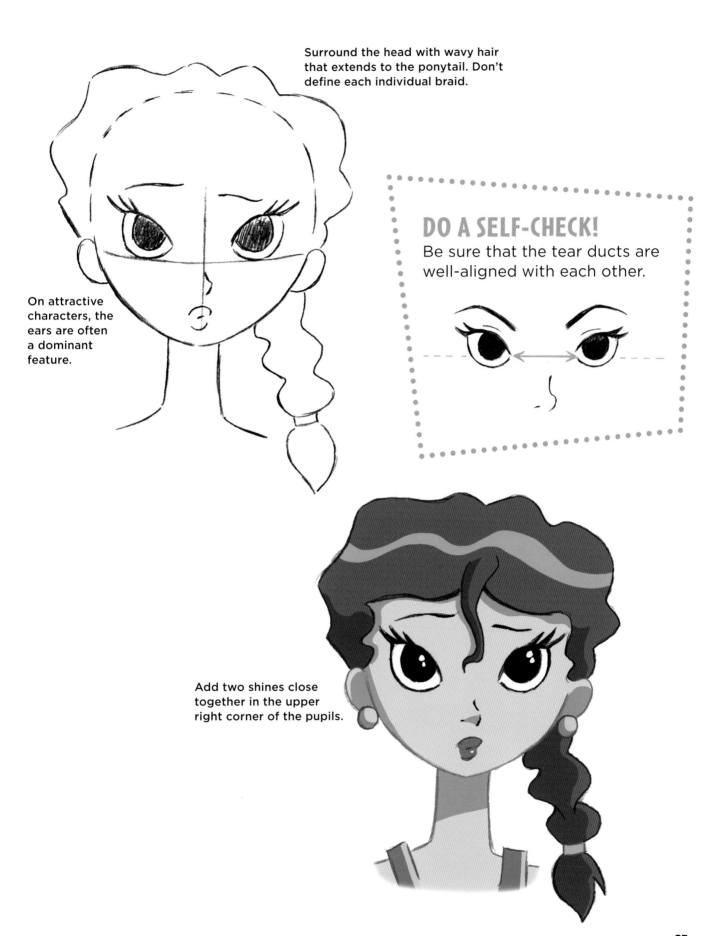

Surround the head with wavy hair that extends to the ponytail. Don't define each individual braid.

On attractive characters, the ears are often a dominant feature.

DO A SELF-CHECK!
Be sure that the tear ducts are well-aligned with each other.

Add two shines close together in the upper right corner of the pupils.

27

More About Eyes

When the eyes glance to the side, the pupils become tall and thin, and the whites of the eyes dominate. This creates a cute and attractive look for your character.

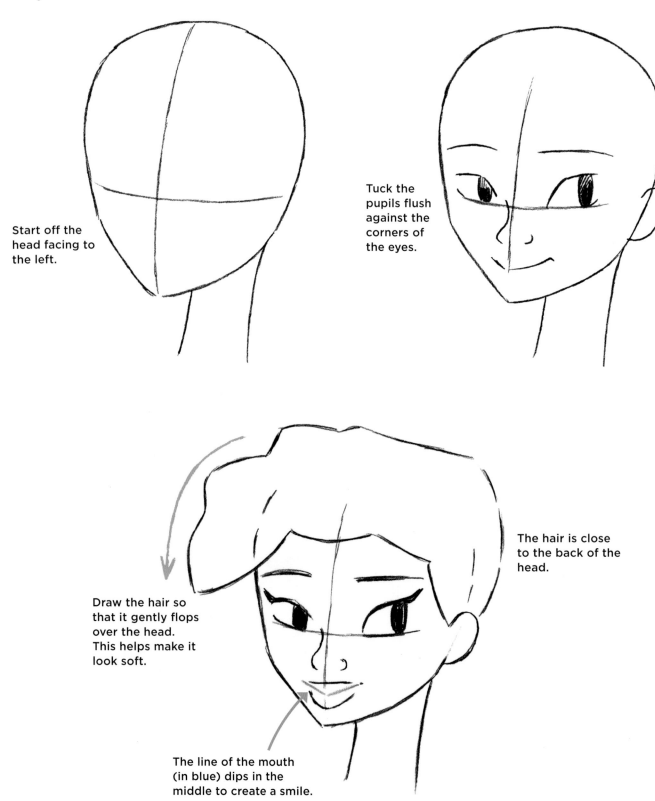

Start off the head facing to the left.

Tuck the pupils flush against the corners of the eyes.

The hair is close to the back of the head.

Draw the hair so that it gently flops over the head. This helps make it look soft.

The line of the mouth (in blue) dips in the middle to create a smile.

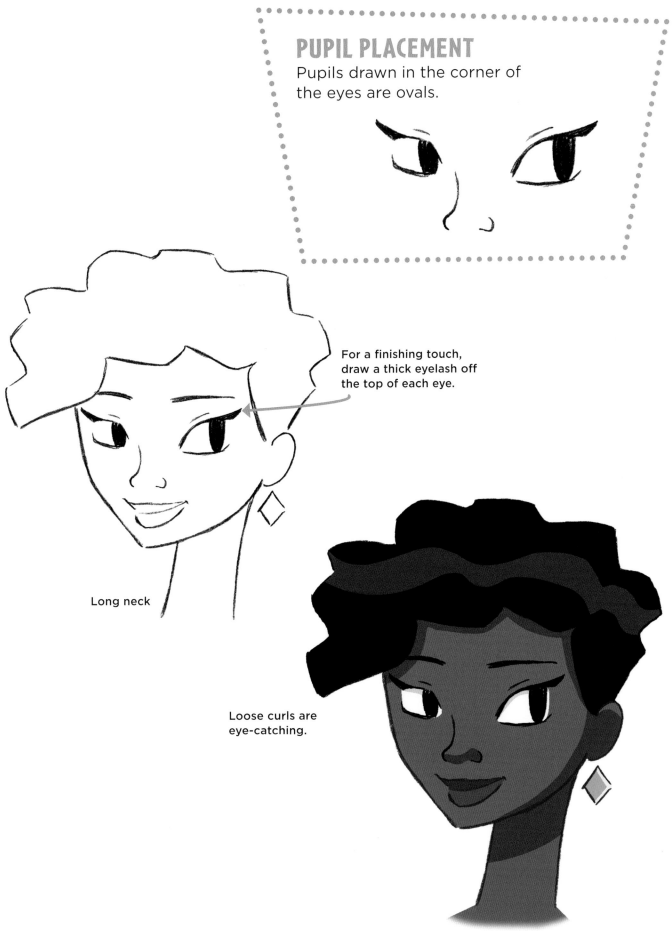

PUPIL PLACEMENT
Pupils drawn in the corner of the eyes are ovals.

For a finishing touch, draw a thick eyelash off the top of each eye.

Long neck

Loose curls are eye-catching.

It's About the Hair

An appealing hairstyle greatly enhances a character's look. I'll demonstrate some of the most popular haircuts in the following three characters. If you like, you can add your own modifications—make the hair wavier or straighter, lengthen it or flip it out at the bottom.

Bangs

Bangs are a symmetrical look. They're drawn either straight across or slightly curved. To make them appear natural, you can indicate a few strands in them.

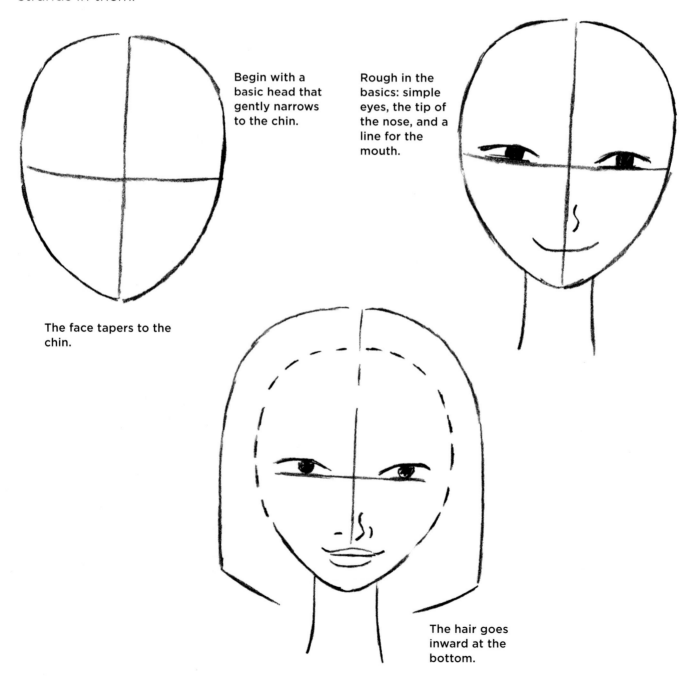

Begin with a basic head that gently narrows to the chin.

Rough in the basics: simple eyes, the tip of the nose, and a line for the mouth.

The face tapers to the chin.

The hair goes inward at the bottom.

The bangs are curved and cover the eyebrows.

Draw short, wide-spaced strands for a more realistic look.

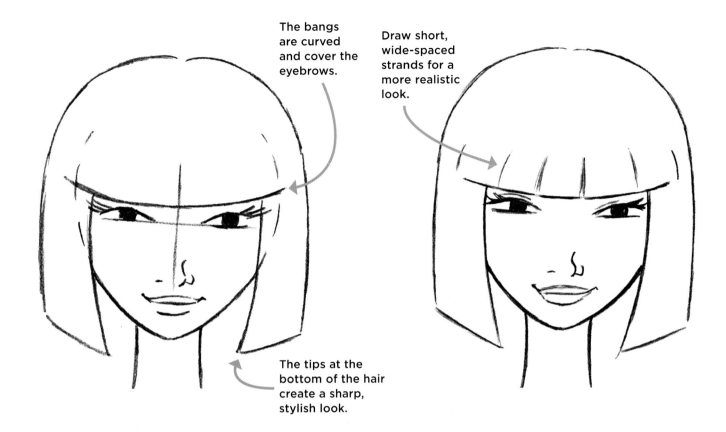

The tips at the bottom of the hair create a sharp, stylish look.

Add an uneven shine across the top of the hair.

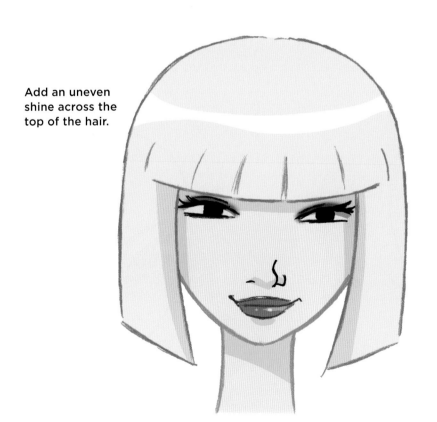

Long Hair

Drawing long hair can be a little tricky. By dividing the drawing process into two stages, it becomes easier. First, sketch the outline of the hair. Next, draw the interior of the hair. Let's see how it works.

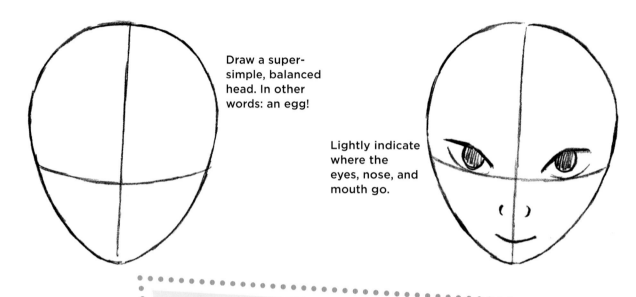

Draw a super-simple, balanced head. In other words: an egg!

Lightly indicate where the eyes, nose, and mouth go.

HINT

Draw the eyeballs looking upward, but leave them partially covered by the eyelids. Give the eyelashes a big flip up.

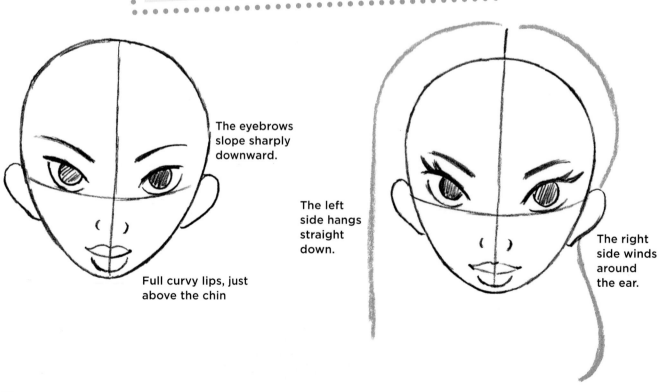

The eyebrows slope sharply downward.

Full curvy lips, just above the chin

The left side hangs straight down.

The right side winds around the ear.

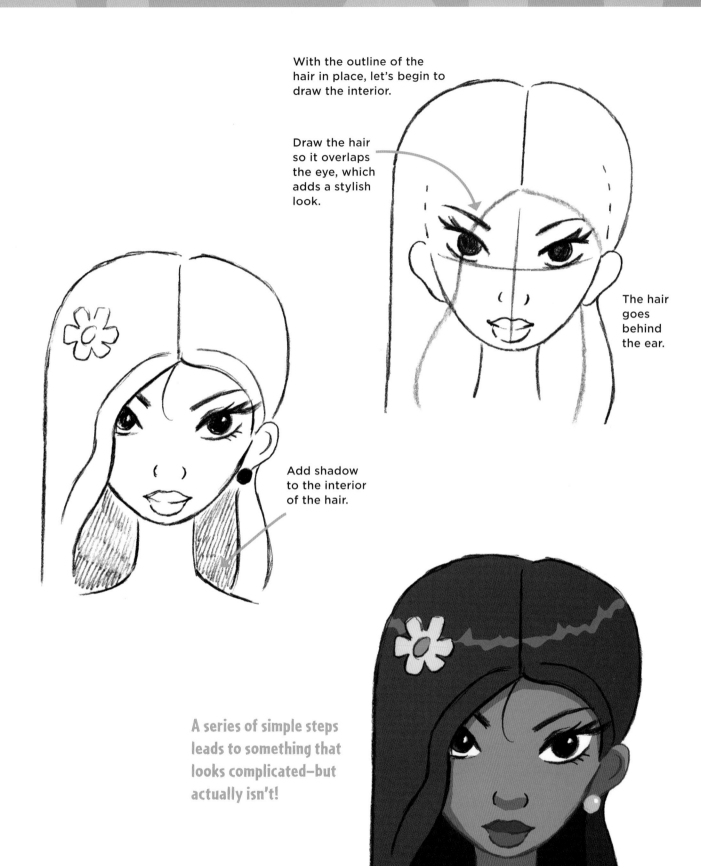

With the outline of the hair in place, let's begin to draw the interior.

Draw the hair so it overlaps the eye, which adds a stylish look.

The hair goes behind the ear.

Add shadow to the interior of the hair.

A series of simple steps leads to something that looks complicated—but actually isn't!

The Ponytail

When newer artists draw a ponytail, they don't always pay attention to the rest of the hair on the head. But the ponytail and the hair on top of the head are not two separate entities—they form a single hairstyle. Let's see how to draw them so that they work together.

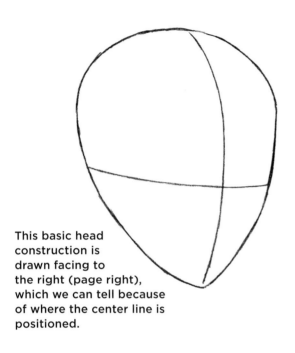

This basic head construction is drawn facing to the right (page right), which we can tell because of where the center line is positioned.

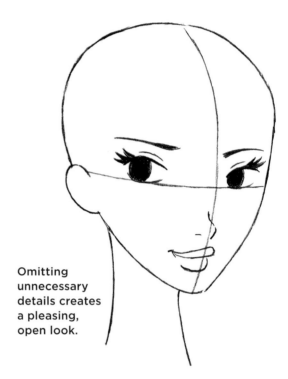

Omitting unnecessary details creates a pleasing, open look.

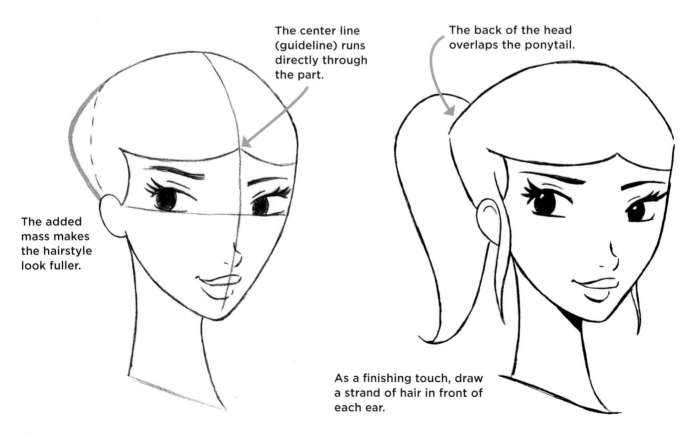

The center line (guideline) runs directly through the part.

The added mass makes the hairstyle look fuller.

The back of the head overlaps the ponytail.

As a finishing touch, draw a strand of hair in front of each ear.

Kid Heads

The average cartoon kid has a wide head compared to his or her body. But the features of the face (eyes, nose, and mouth) are generally small. This creates a round look, which is cute and funny.

Draw a wide head construction, with the eye line (horizontal guideline) closer to the bottom than to the top of the head.

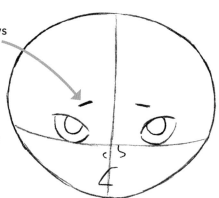

Draw little eyebrows directly over the pupils of the eyes.

Draw the eyes far apart, but the nose and mouth remain close together.

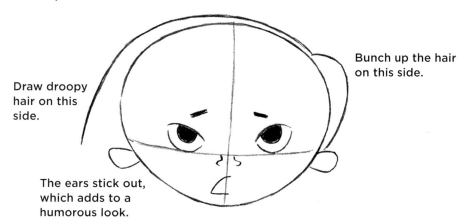

Draw droopy hair on this side.

Bunch up the hair on this side.

The ears stick out, which adds to a humorous look.

Draw a long hairline across the forehead.

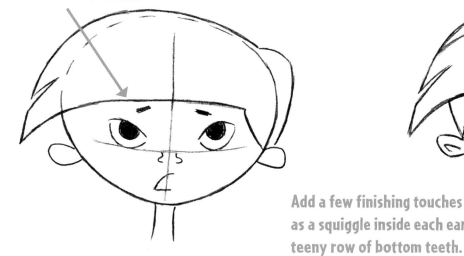

Add a few finishing touches such as a squiggle inside each ear and a teeny row of bottom teeth.

Small Nose and Mouth

The eyes can be made to look oversized simply by drawing a small nose and mouth. This is an effective alternative to drawing giant eyes.

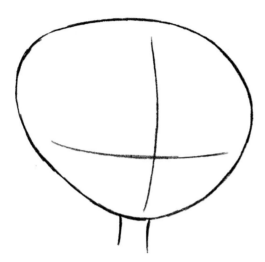

The features of the face will be grouped tightly around the center of the X made by the guidelines. (Note the skinny neck—a telltale sign of kid characters.)

Kids are drawn with large pupils more often than characters of other ages.

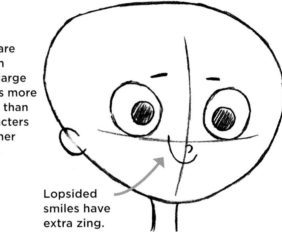

Lopsided smiles have extra zing.

The edges of the hair stick out for a slightly awkward look.

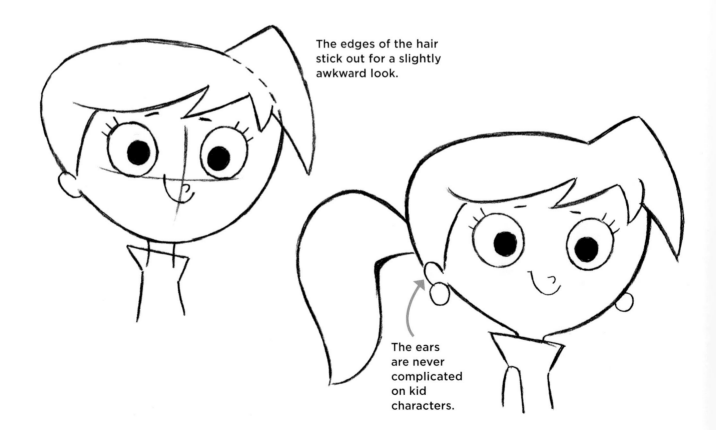

The ears are never complicated on kid characters.

36

The Oversized Head

Kid characters have big heads but slight bodies. Part of what makes their heads appear large is the contrast with a skinny neck. Another is widely spaced eyes. It can be based on any rounded shape—as long as its simple.

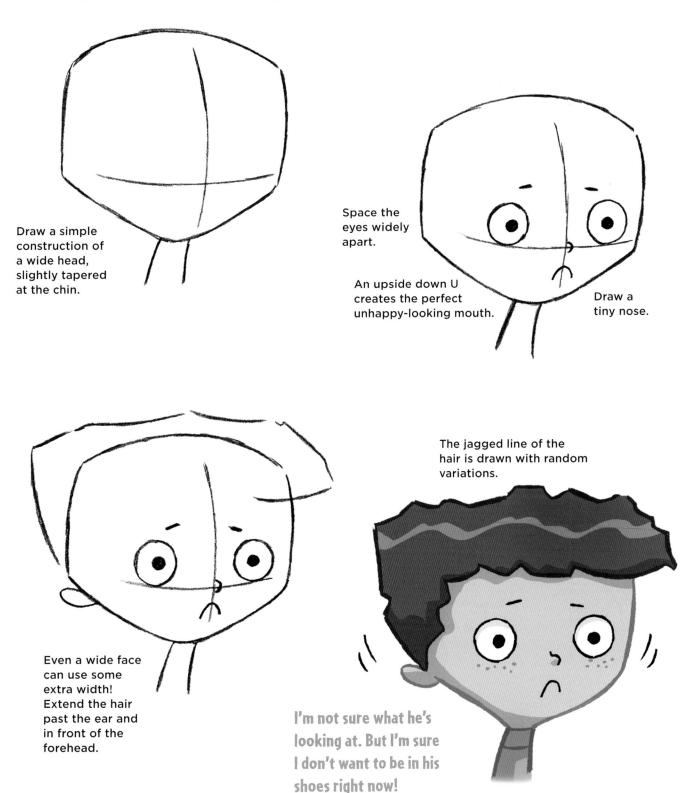

Draw a simple construction of a wide head, slightly tapered at the chin.

Space the eyes widely apart.

An upside down U creates the perfect unhappy-looking mouth.

Draw a tiny nose.

Even a wide face can use some extra width! Extend the hair past the ear and in front of the forehead.

The jagged line of the hair is drawn with random variations.

I'm not sure what he's looking at. But I'm sure I don't want to be in his shoes right now!

Teens

Teen characters generally have more stylish haircuts than kids. The size of their eyes is also reduced, mainly on boys.

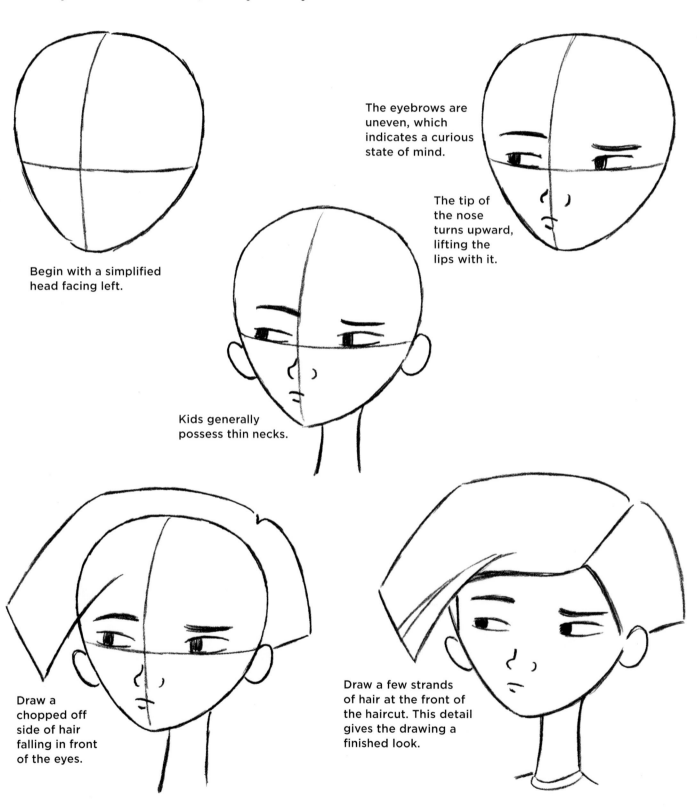

Begin with a simplified head facing left.

The eyebrows are uneven, which indicates a curious state of mind.

The tip of the nose turns upward, lifting the lips with it.

Kids generally possess thin necks.

Draw a chopped off side of hair falling in front of the eyes.

Draw a few strands of hair at the front of the haircut. This detail gives the drawing a finished look.

Girls

Teen girls can be drawn with a slight indication of makeup, mainly on the eyelashes. Their eyes usually remain large. They also have expensive hairstyles. (Now you know where their allowances went.)

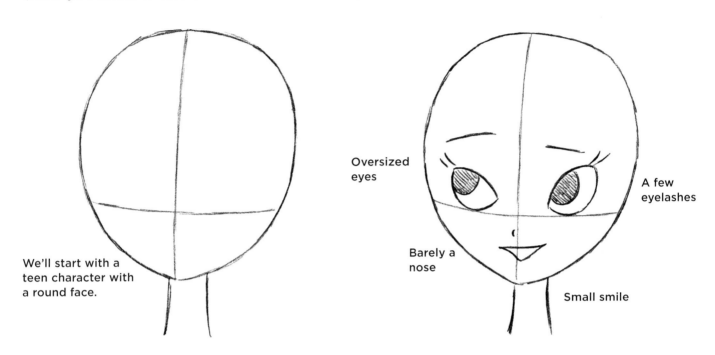

We'll start with a teen character with a round face.

Oversized eyes

A few eyelashes

Barely a nose

Small smile

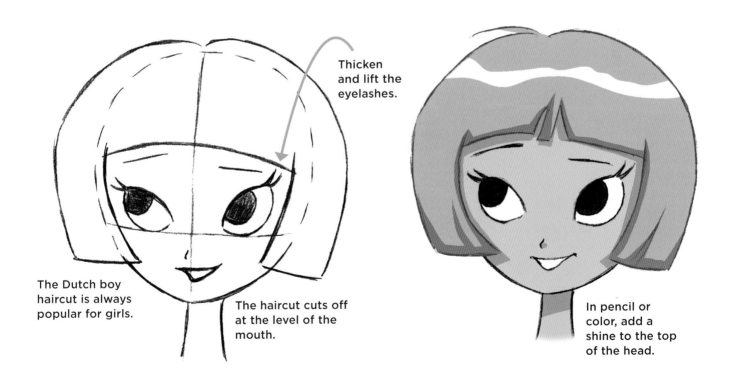

Thicken and lift the eyelashes.

The Dutch boy haircut is always popular for girls.

The haircut cuts off at the level of the mouth.

In pencil or color, add a shine to the top of the head.

Older Teens

Older teens, ages 15-17, have more angular faces. They're developing into adults and we need to find a way to show that. Many animated feature films approach it like this: They construct the characters with the idealized look of leading actors, while still retaining the proportions of youth. One of the best ways is to adjust the basic proportions, as shown in step one. Let's see how it works.

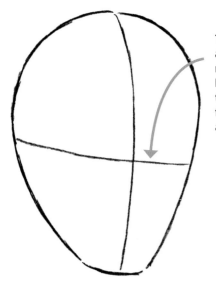

The eye line now appears in the middle of the head, not low on the face as it did for drawing kids and younger teens.

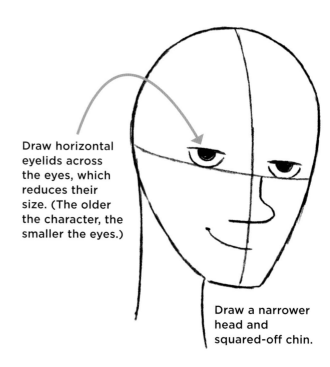

Draw horizontal eyelids across the eyes, which reduces their size. (The older the character, the smaller the eyes.)

Draw a narrower head and squared-off chin.

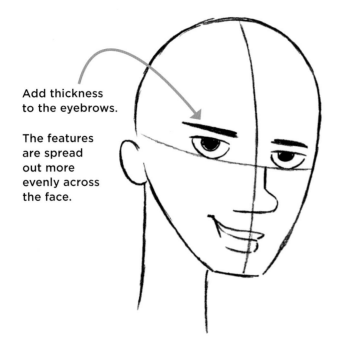

Add thickness to the eyebrows.

The features are spread out more evenly across the face.

HINT
These basic guidelines are designed to get you started. You can individualize your drawing to your personal taste.

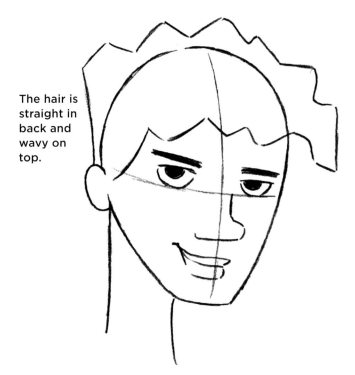

The hair is straight in back and wavy on top.

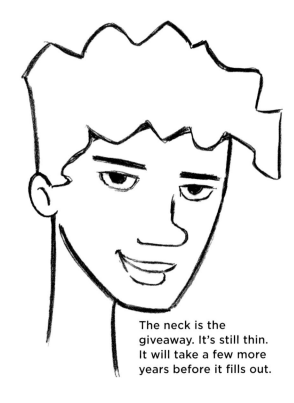

The neck is the giveaway. It's still thin. It will take a few more years before it fills out.

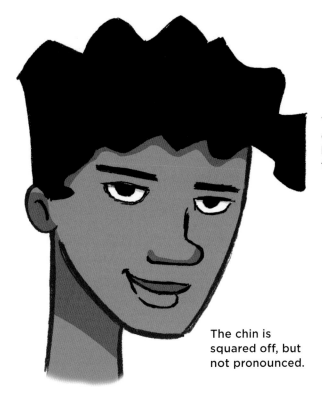

The hair extends off the head and kind of levitates there.

The chin is squared off, but not pronounced.

Basic Character Types

Now we'll learn to draw the heads of some essential cartoon character types.

Mr. Humble

Egotistical cartoon characters are fun to draw. They're people who really would like to be humble, but since they're so amazing, it would be wrong not to tell everyone about it.

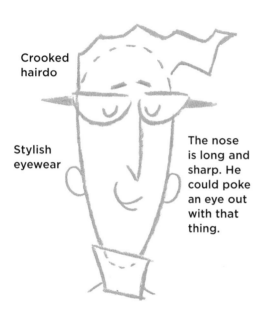

Crooked hairdo

Stylish eyewear

The nose is long and sharp. He could poke an eye out with that thing.

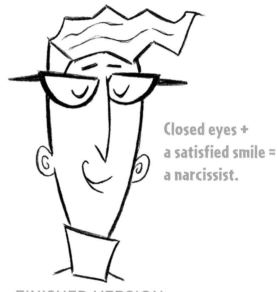

Closed eyes + a satisfied smile = a narcissist.

FINISHED VERSION

Wallflower

She's a sweet person, but a little shy. Well, very shy. But if played right, this character type has special appeal. Her character has what is called a big *arc*, meaning that she starts out one place in the story (shy), but ends up in a much different place (self-assured).

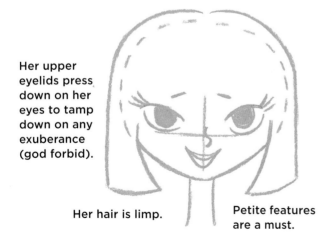

Her upper eyelids press down on her eyes to tamp down on any exuberance (god forbid).

Her hair is limp.

Petite features are a must.

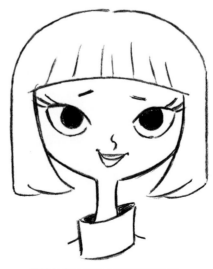

FINISHED VERSION

The Worrier

Meet the worrier. It doesn't matter how unlikely something is, if it can happen, he's worried about it. He worries about climate change—on Venus! Audiences like to watch this type because he does all the worrying for them. The only thing he doesn't worry about is his homework. He still hands it in late.

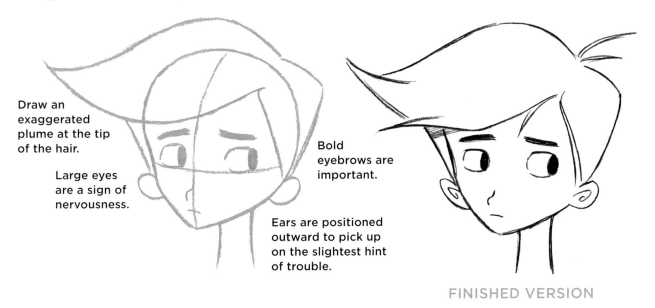

Draw an exaggerated plume at the tip of the hair.

Large eyes are a sign of nervousness.

Bold eyebrows are important.

Ears are positioned outward to pick up on the slightest hint of trouble.

FINISHED VERSION

Mr. Sarcastic

This sarcastic observer is a famous type. He can get away with droll comments like no one else because he's funny. He's the kind of guy who feels his parachute snap off in mid air and murmurs, "So much for my dinner plans tonight."

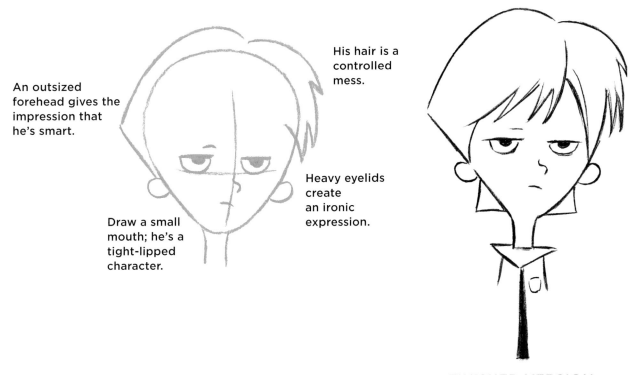

An outsized forehead gives the impression that he's smart.

His hair is a controlled mess.

Draw a small mouth; he's a tight-lipped character.

Heavy eyelids create an ironic expression.

FINISHED VERSION

43

Mr. Conventional

He's a mid-level executive who believes in team spirit, therefore, he's always getting out-maneuvered for a promotion. He's married with children and a goldendoodle. Go team!

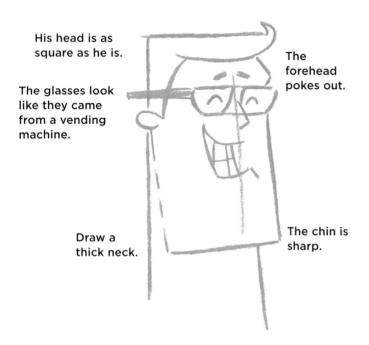

His head is as square as he is.

The glasses look like they came from a vending machine.

The forehead pokes out.

Draw a thick neck.

The chin is sharp.

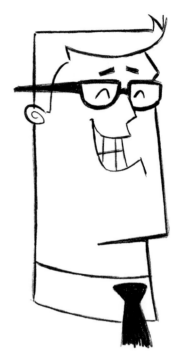

FINISHED VERSION

Joyful Type

Sometimes, you need a character to signal the audience when it's time to smile. This character type is the visual equivalent of a sound track. She's a great reactor. When she smiles or laughs, the scene becomes happy.

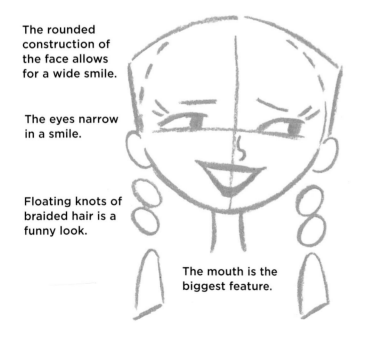

The rounded construction of the face allows for a wide smile.

The eyes narrow in a smile.

Floating knots of braided hair is a funny look.

The mouth is the biggest feature.

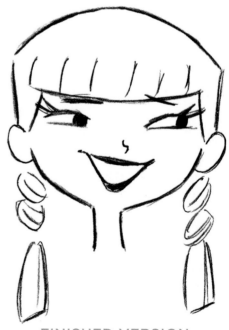

FINISHED VERSION

Irritated Type

The perpetually annoyed type is hilarious in cartoons. In real life, not so much. What aggravates her? Just about anything. For example, if someone blinks their eyes too often, how is she supposed to deal with that!

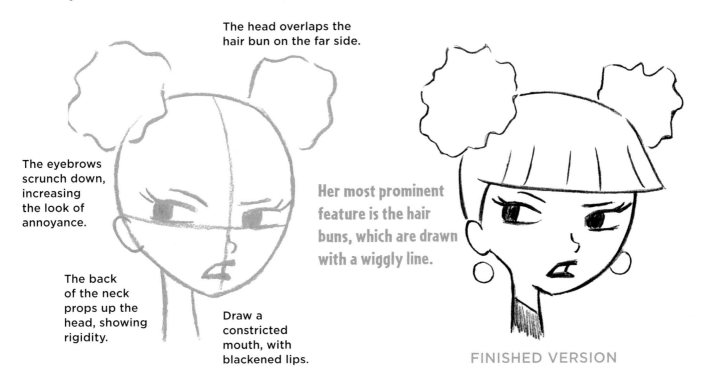

The head overlaps the hair bun on the far side.

The eyebrows scrunch down, increasing the look of annoyance.

The back of the neck props up the head, showing rigidity.

Draw a constricted mouth, with blackened lips.

Her most prominent feature is the hair buns, which are drawn with a wiggly line.

FINISHED VERSION

The Smug Mug

Have you ever known someone who thinks she's smarter than everyone else? This character type has a way of savoring every little victory, over and over, until you just want to take up a collection for a vacation for her—to Mars!

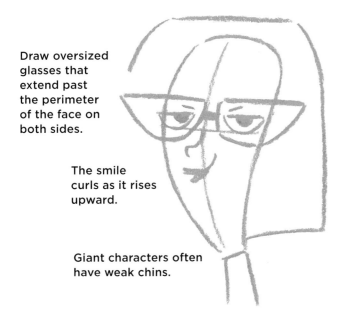

Draw oversized glasses that extend past the perimeter of the face on both sides.

The smile curls as it rises upward.

Giant characters often have weak chins.

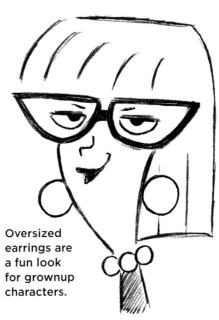

Oversized earrings are a fun look for grownup characters.

FINISHED VERSION

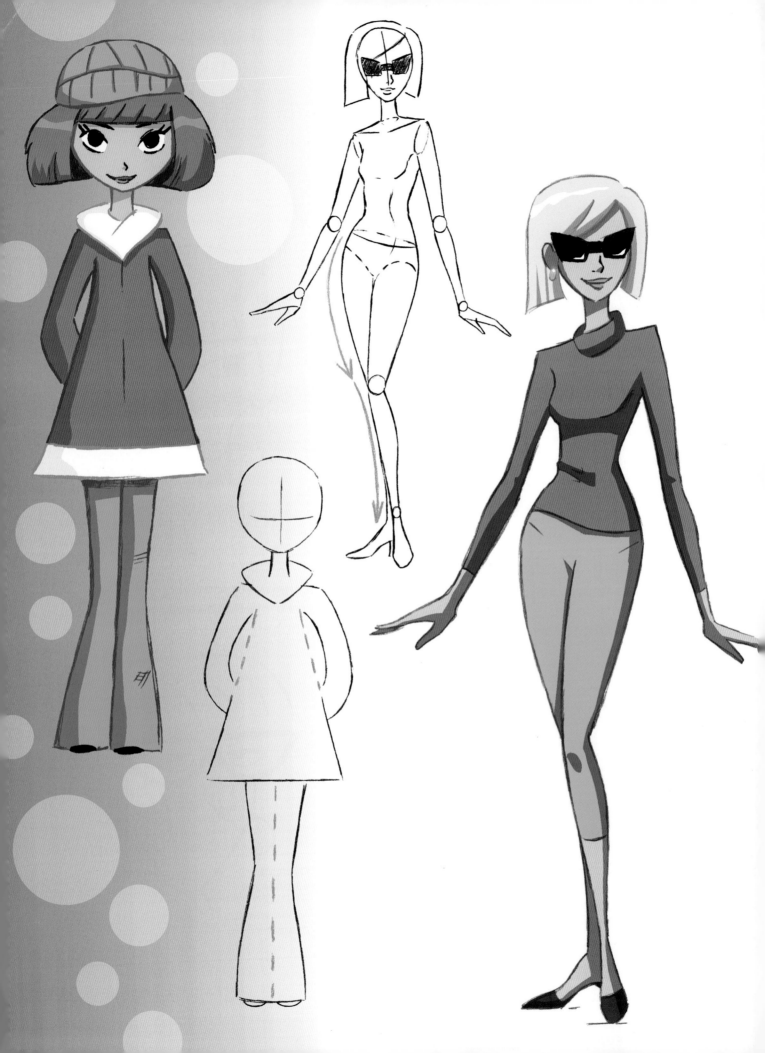

Simplifying the Body

Why are cartoon bodies funnier than real bodies? Because cartoons emphasize the parts of the body that real people try to hide! The proportions are exaggerated. The head is much larger on a cartoon body than it is on a real person. We also omit details when drawing the cartoon body and focus instead on how different parts of the figure flow into one another. But the secret still lies in starting off with the basics—and staying with them—through all of the steps.

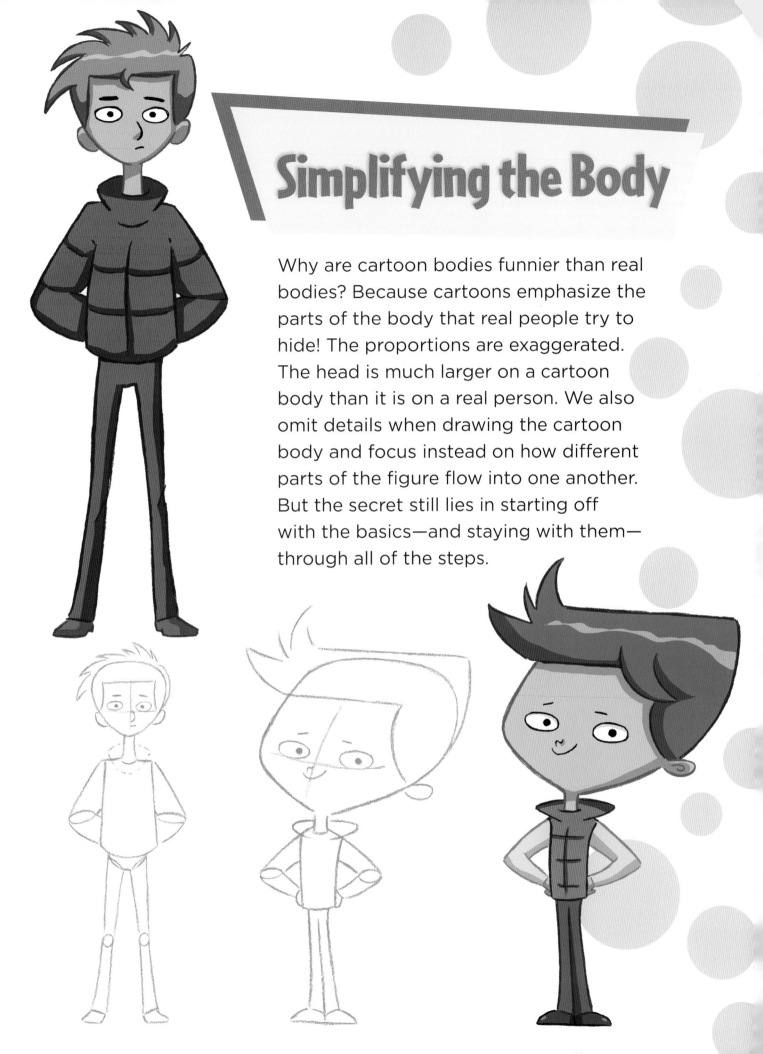

Body Foundations

The foundation of the body begins with a few major, simplified sections.

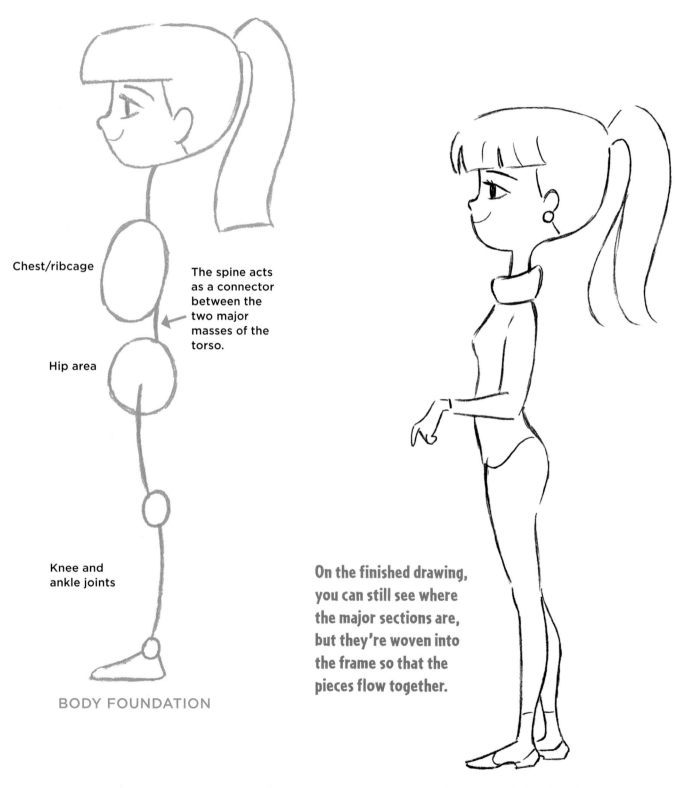

Chest/ribcage

The spine acts as a connector between the two major masses of the torso.

Hip area

Knee and ankle joints

BODY FOUNDATION

On the finished drawing, you can still see where the major sections are, but they're woven into the frame so that the pieces flow together.

FINISHED DRAWING

48

A Hint About Drawing the Back

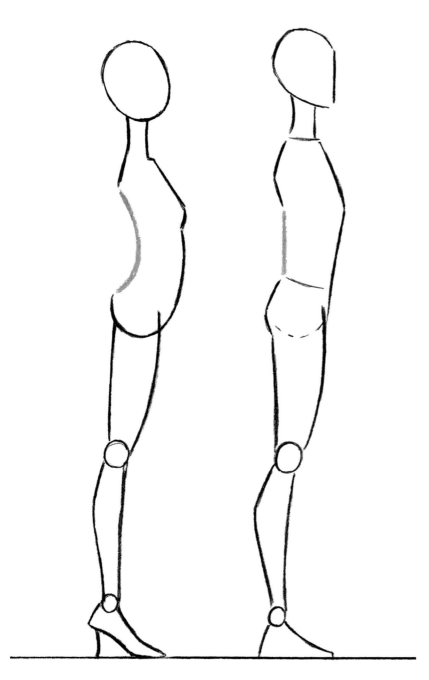

SCOOPED
The female character's back has a scooped shape.

STRAIGHT
The male's back is less flexible.

NATURAL FLOW
The front and back can be drawn as parallel lines that curve in and out in unison. This creates a natural-looking flow to the character.

Proportions of the Upper Body

Now let's focus on the upper body—the area between the shoulders and hips. The torso of male and female characters is built on three prominent proportions: the width of the shoulders, the width of the hips, and the height of the waistline.

The female character has a torso that's pinched in the middle. The shoulders are approximately the same width as the hips.

WHERE TO PLACE THE BELTLINE

Female characters have significantly higher beltlines than males.

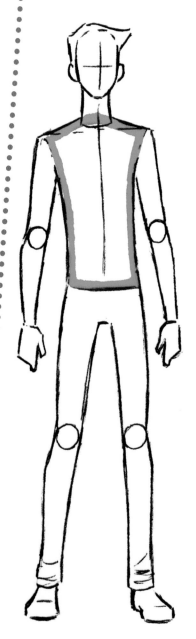

The male torso is wide on top, but narrower at the hips. Unlike the female torso, the waist doesn't indent so much.

Another Hint About Proportions

A character retains his basic proportions in any direction unless he bends or makes an extreme move. Cartoonists use proportions to make sure the character is recognizable at different angles.

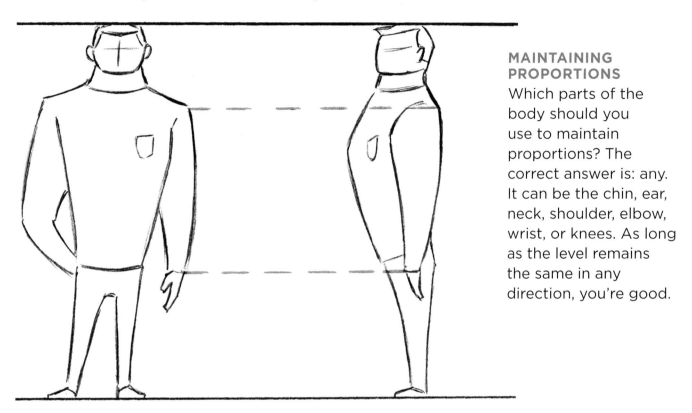

MAINTAINING PROPORTIONS
Which parts of the body should you use to maintain proportions? The correct answer is: any. It can be the chin, ear, neck, shoulder, elbow, wrist, or knees. As long as the level remains the same in any direction, you're good.

WHAT ABOUT POSTURE?
If a character slumps when he stands, the proportions can be maintained by drawing the same posture in other directions, too.

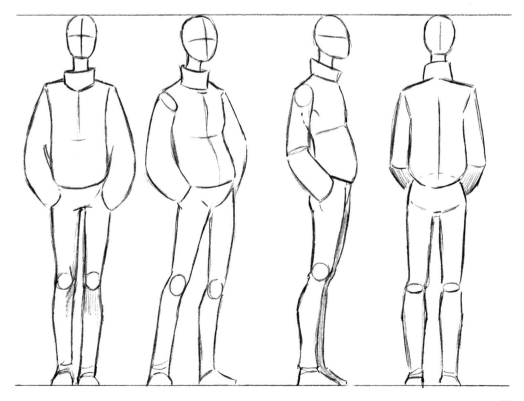

Simplifying the Clothed Body

Clothes make it easier to simplify the body. To demonstrate, I'll start with a character in a winter coat, which I'll streamline by filling in the sides of the body. This will give the cartoon a flat look, which is a style that many cartoonists try to achieve in their work.

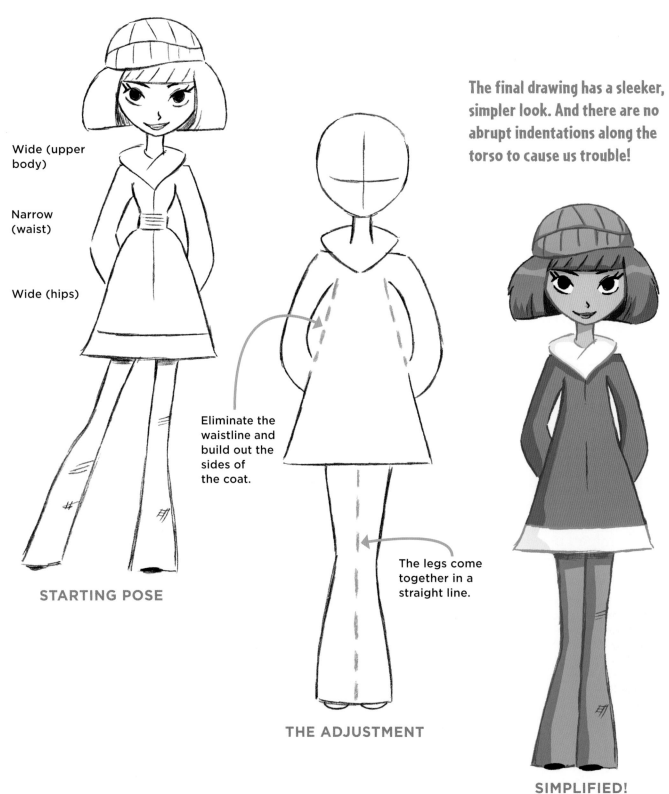

Wide (upper body)

Narrow (waist)

Wide (hips)

STARTING POSE

Eliminate the waistline and build out the sides of the coat.

The legs come together in a straight line.

THE ADJUSTMENT

The final drawing has a sleeker, simpler look. And there are no abrupt indentations along the torso to cause us trouble!

SIMPLIFIED!

Symmetry and Flow

Maybe you were like this, too: As a beginning artist I thought it was important to make everything line up evenly, such as the arm and leg positions. Where I got this idea is anyone's guess. But I was wrong. Symmetry is usually less interesting than asymmetry. Let's compare two poses.

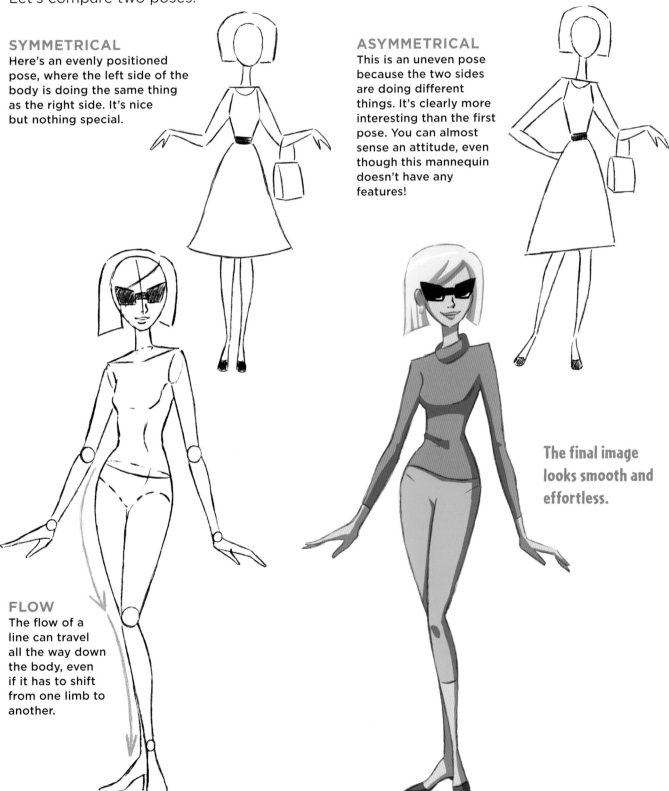

SYMMETRICAL
Here's an evenly positioned pose, where the left side of the body is doing the same thing as the right side. It's nice but nothing special.

ASYMMETRICAL
This is an uneven pose because the two sides are doing different things. It's clearly more interesting than the first pose. You can almost sense an attitude, even though this mannequin doesn't have any features!

The final image looks smooth and effortless.

FLOW
The flow of a line can travel all the way down the body, even if it has to shift from one limb to another.

How Age Changes the Proportions

As a character ages, his or her proportions change. To understand how this works, let's look at the example of a young boy and compare it to an older version of the same character.

HINT
The younger the character, the more you can exaggerate the proportions.

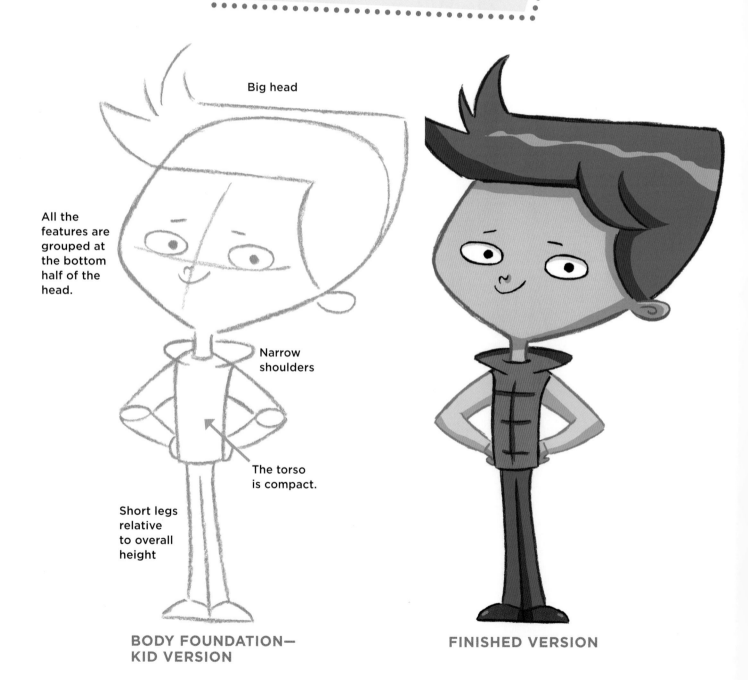

Big head

All the features are grouped at the bottom half of the head.

Narrow shoulders

The torso is compact.

Short legs relative to overall height

BODY FOUNDATION— KID VERSION

FINISHED VERSION

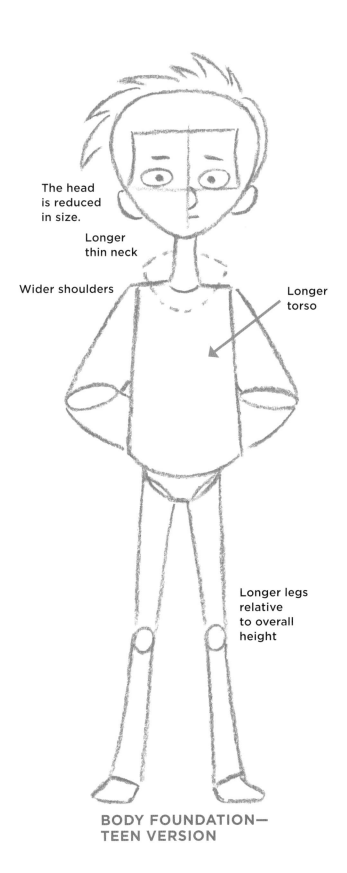

The head is reduced in size.

Longer thin neck

Wider shoulders

Longer torso

Longer legs relative to overall height

BODY FOUNDATION— TEEN VERSION

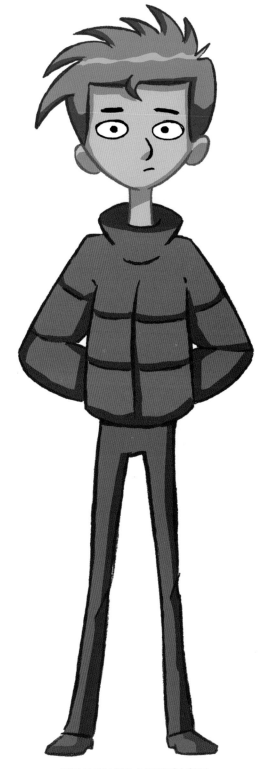

FINISHED VERSION

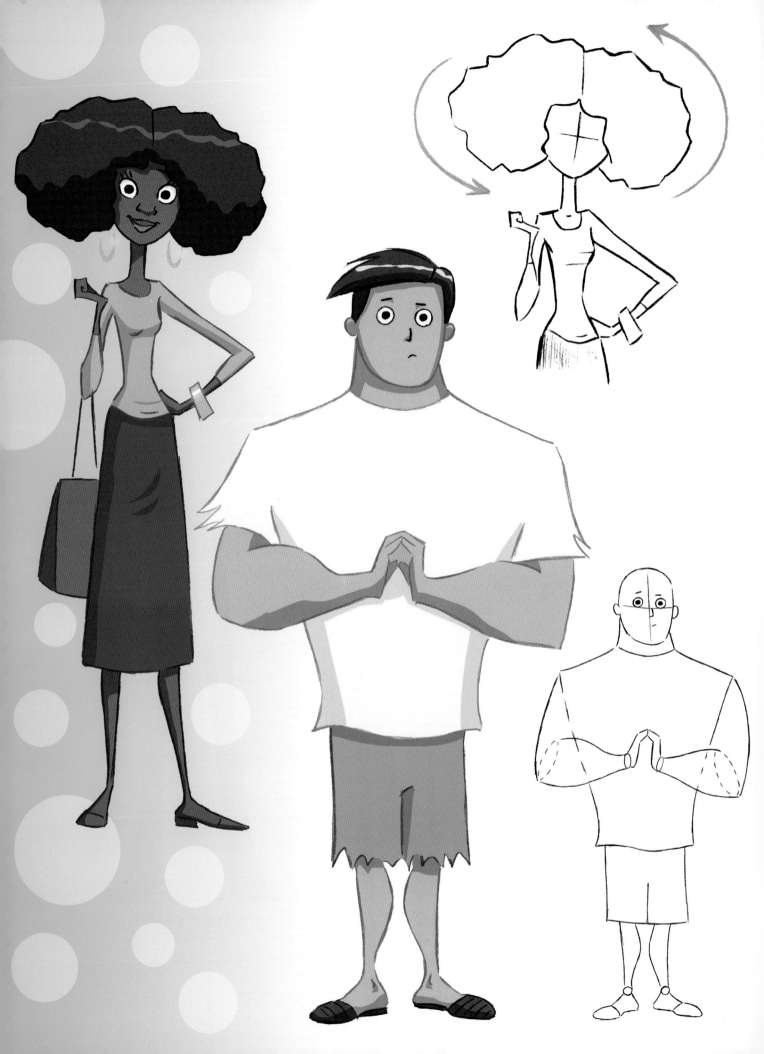

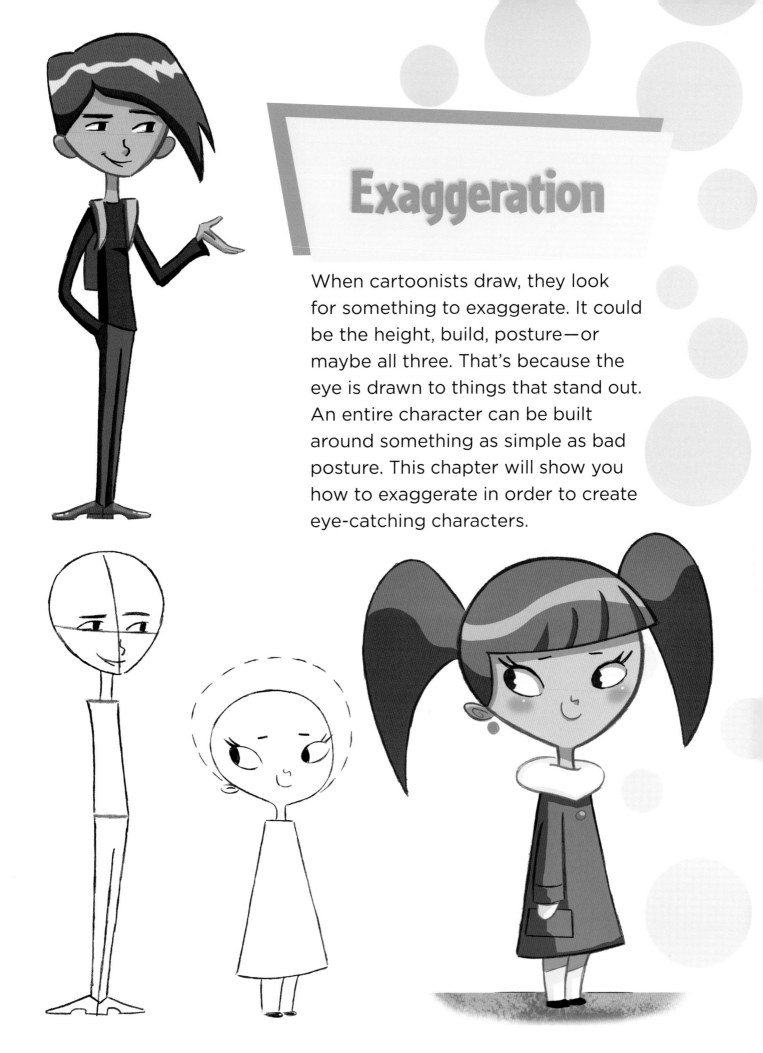

Exaggeration

When cartoonists draw, they look for something to exaggerate. It could be the height, build, posture—or maybe all three. That's because the eye is drawn to things that stand out. An entire character can be built around something as simple as bad posture. This chapter will show you how to exaggerate in order to create eye-catching characters.

The String Bean Body

An extra-narrow body is a great starting point for drawing kids and teens.
This character type, with a huge head and slim body, is featured everywhere
in movie animation. It's entertaining and versatile.

TIP
Exaggerate body type.

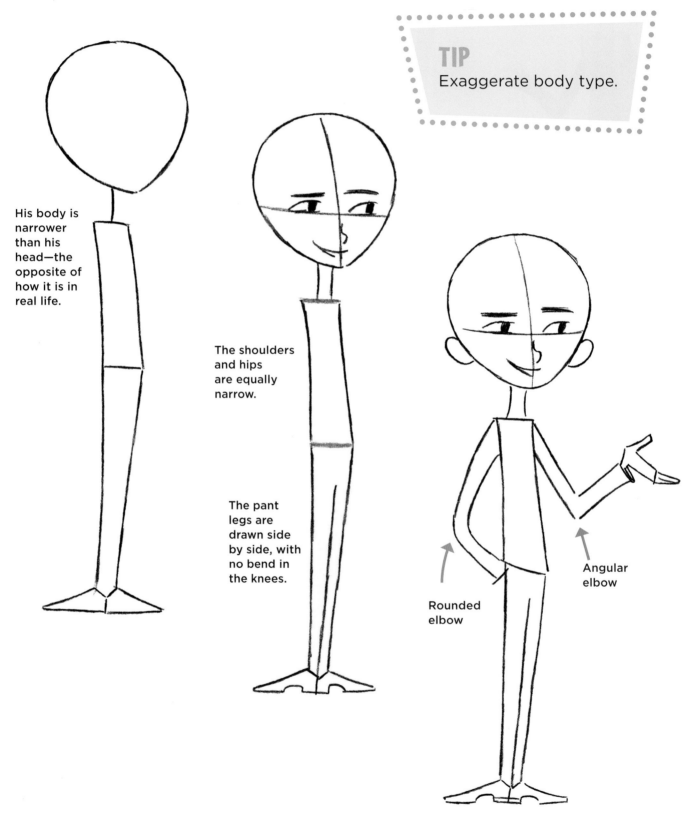

His body is narrower than his head—the opposite of how it is in real life.

The shoulders and hips are equally narrow.

The pant legs are drawn side by side, with no bend in the knees.

Rounded elbow

Angular elbow

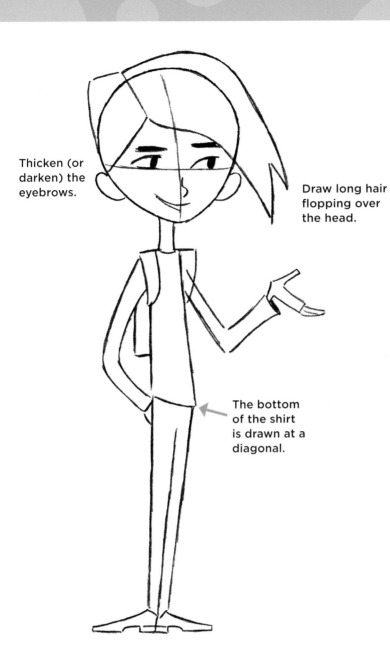

Thicken (or darken) the eyebrows.

Draw long hair flopping over the head.

The bottom of the shirt is drawn at a diagonal.

HINT

When two shoes are drawn perpendicular to each other, leave space under each arch.

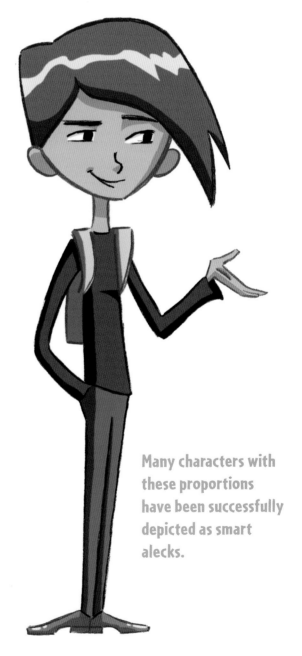

Many characters with these proportions have been successfully depicted as smart alecks.

The Giant

On the other end of the spectrum is the overbuilt physique, which includes funny superheroes, cavemen, and monsters. But this body can also be used to create friendly, insecure types, which expands the possibilities.

The shoulders are wider than the average SUV.

TIP
Exaggerate muscles.

Long upper body

Short lower body

Small feet are a funny punctuation on big bodies.

Draw giant forearm muscles.

The legs are less muscular.

Draw torn shirtsleeves and jagged shorts.

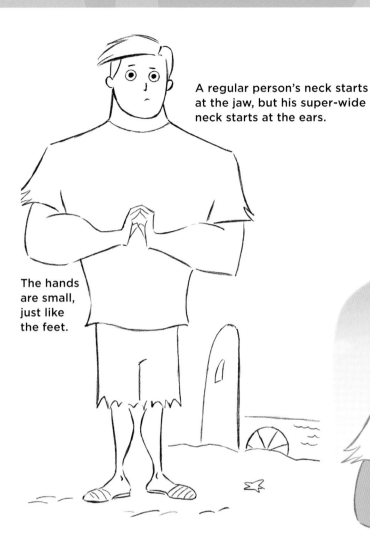

A regular person's neck starts at the jaw, but his super-wide neck starts at the ears.

The hands are small, just like the feet.

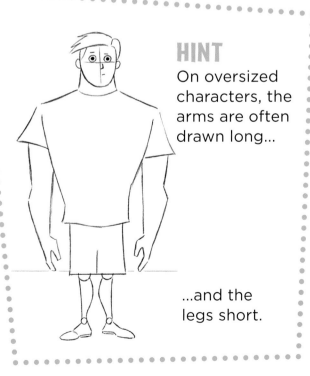

HINT

On oversized characters, the arms are often drawn long...

...and the legs short.

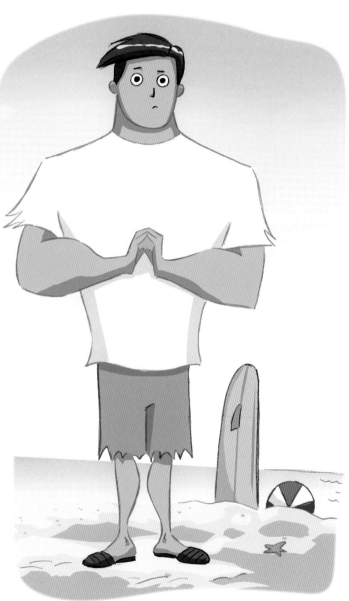

A good hand pose can convey a character's state of mind almost as well as a facial expression.

More About Exaggerating the Head

The "big head" technique is equally good for creating young characters. Avoid drawing a sturdy neck to keep the head on the body. It's funnier if the head looks a little wobbly!

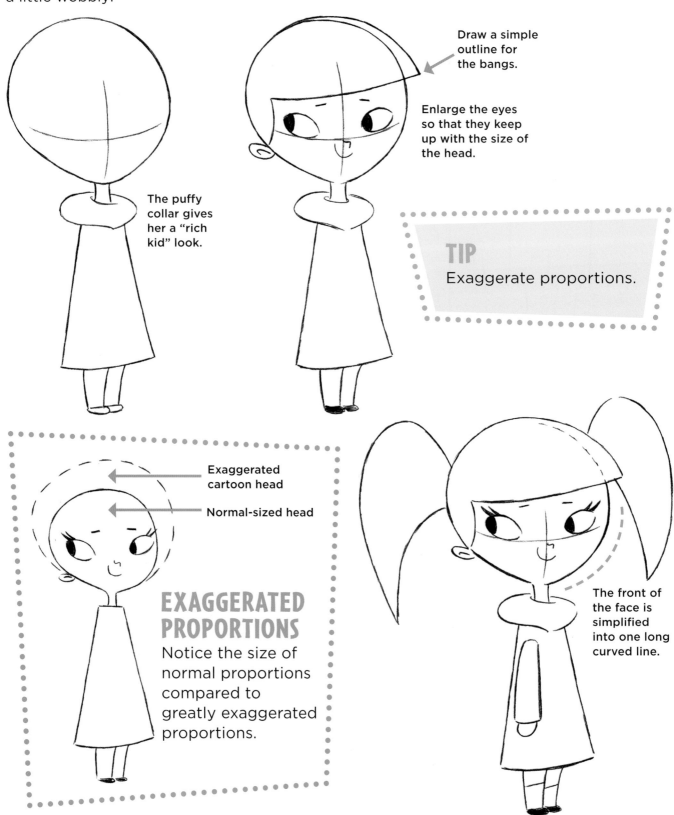

The puffy collar gives her a "rich kid" look.

Draw a simple outline for the bangs.

Enlarge the eyes so that they keep up with the size of the head.

TIP
Exaggerate proportions.

Exaggerated cartoon head

Normal-sized head

EXAGGERATED PROPORTIONS

Notice the size of normal proportions compared to greatly exaggerated proportions.

The front of the face is simplified into one long curved line.

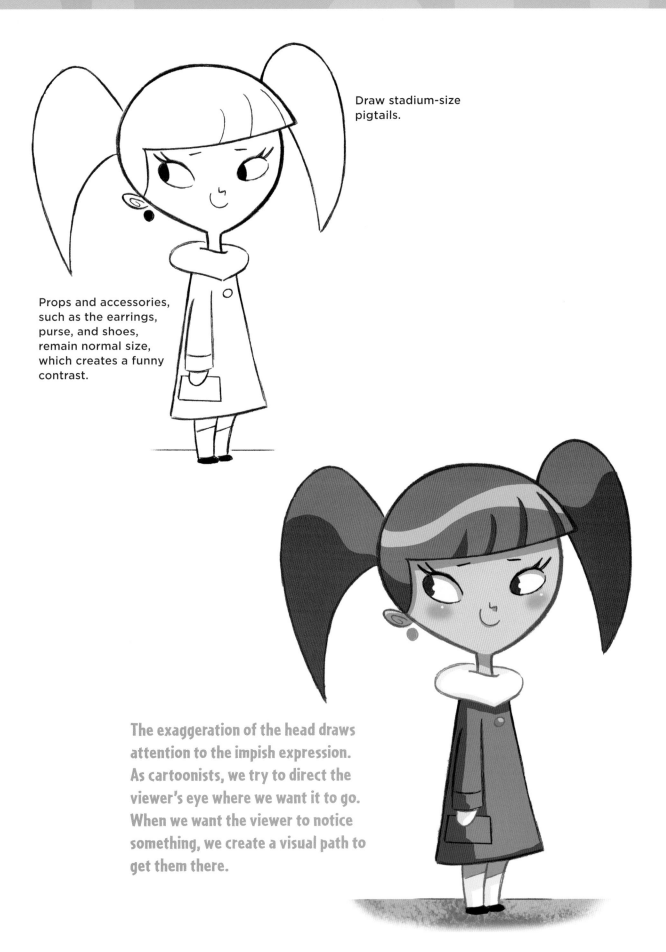

Draw stadium-size pigtails.

Props and accessories, such as the earrings, purse, and shoes, remain normal size, which creates a funny contrast.

The exaggeration of the head draws attention to the impish expression. As cartoonists, we try to direct the viewer's eye where we want it to go. When we want the viewer to notice something, we create a visual path to get them there.

Exaggerating the Hair

Although this hairstyle is exaggerated in size, it retains its shape. Notice, too, that only one aspect of the character—the hairstyle—is exaggerated. The rest is normal. This prevents the character from becoming unwieldy.

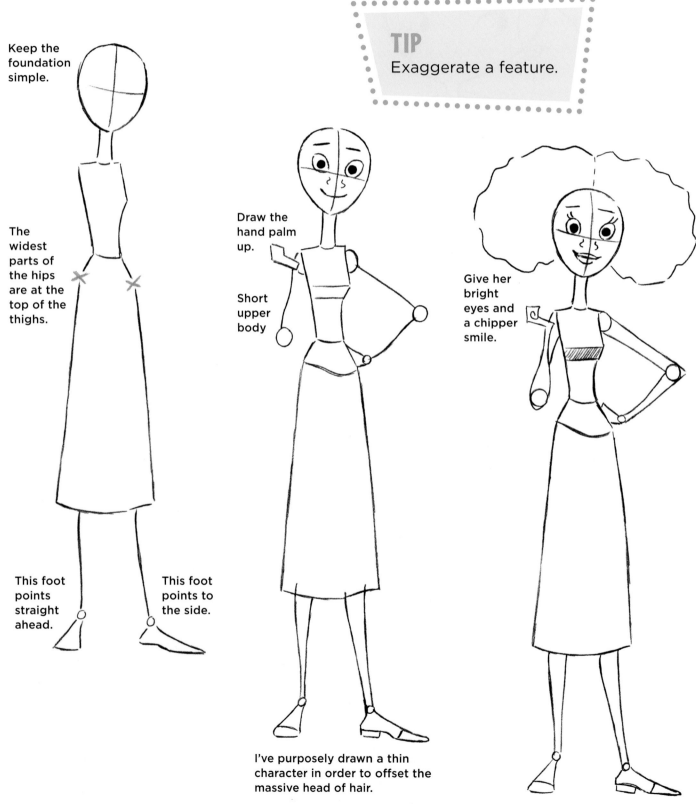

TIP
Exaggerate a feature.

Keep the foundation simple.

The widest parts of the hips are at the top of the thighs.

This foot points straight ahead.

This foot points to the side.

Draw the hand palm up.

Short upper body

I've purposely drawn a thin character in order to offset the massive head of hair.

Give her bright eyes and a chipper smile.

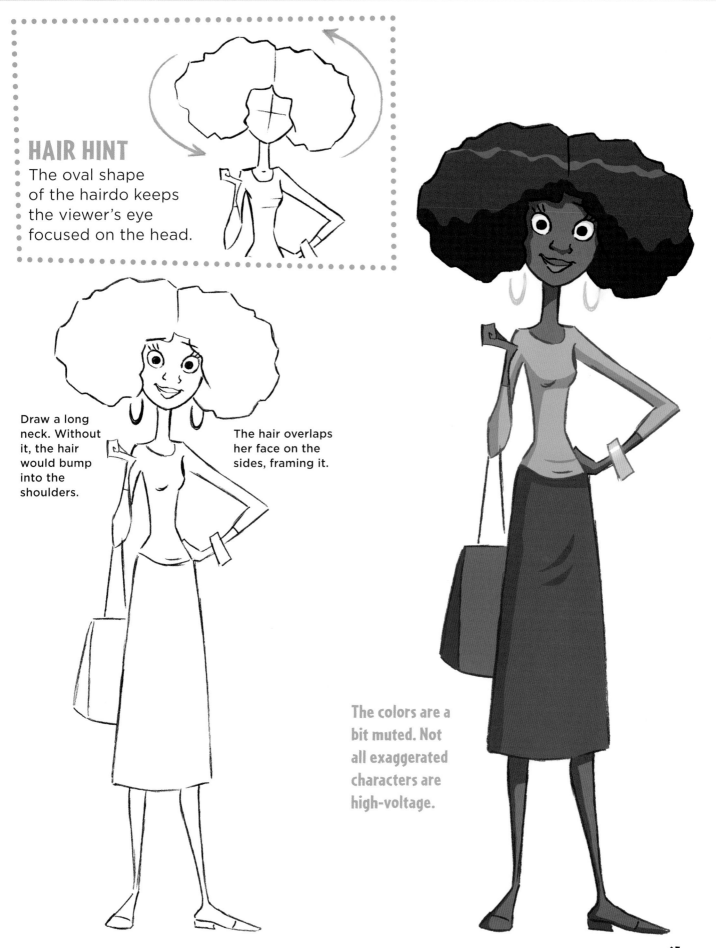

HAIR HINT

The oval shape of the hairdo keeps the viewer's eye focused on the head.

Draw a long neck. Without it, the hair would bump into the shoulders.

The hair overlaps her face on the sides, framing it.

The colors are a bit muted. Not all exaggerated characters are high-voltage.

The Compartmentalized Body

This look was made popular on animated shows from cable TV. It works across all genres, whether your character is a vampire, a princess, or a corporate exec. We've been talking about creating a flow to the body. This is the opposite. The torso and hips snap together, creating an abrupt shift from shape to shape.

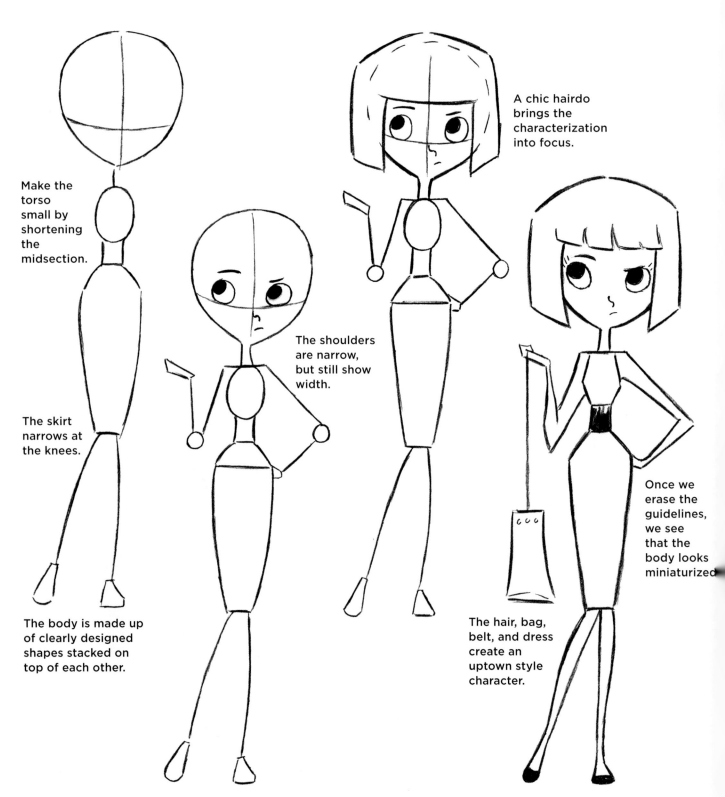

Make the torso small by shortening the midsection.

The skirt narrows at the knees.

The body is made up of clearly designed shapes stacked on top of each other.

The shoulders are narrow, but still show width.

A chic hairdo brings the characterization into focus.

The hair, bag, belt, and dress create an uptown style character.

Once we erase the guidelines, we see that the body looks miniaturized.

66

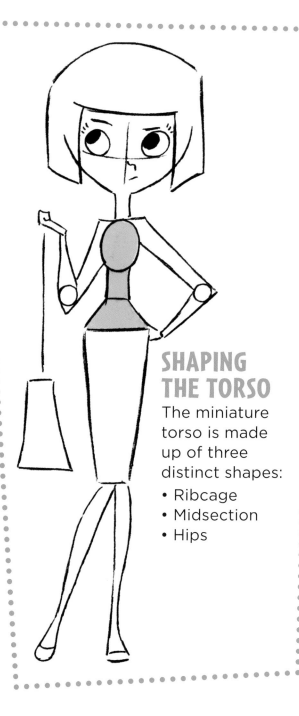

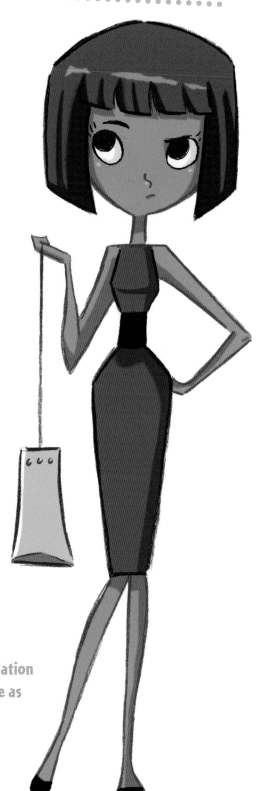

TIP
Exaggerate body shape.

SHAPING THE TORSO

The miniature torso is made up of three distinct shapes:

• Ribcage
• Midsection
• Hips

This character is easy to draw, because the foundation shapes change very little as you refine the drawing.

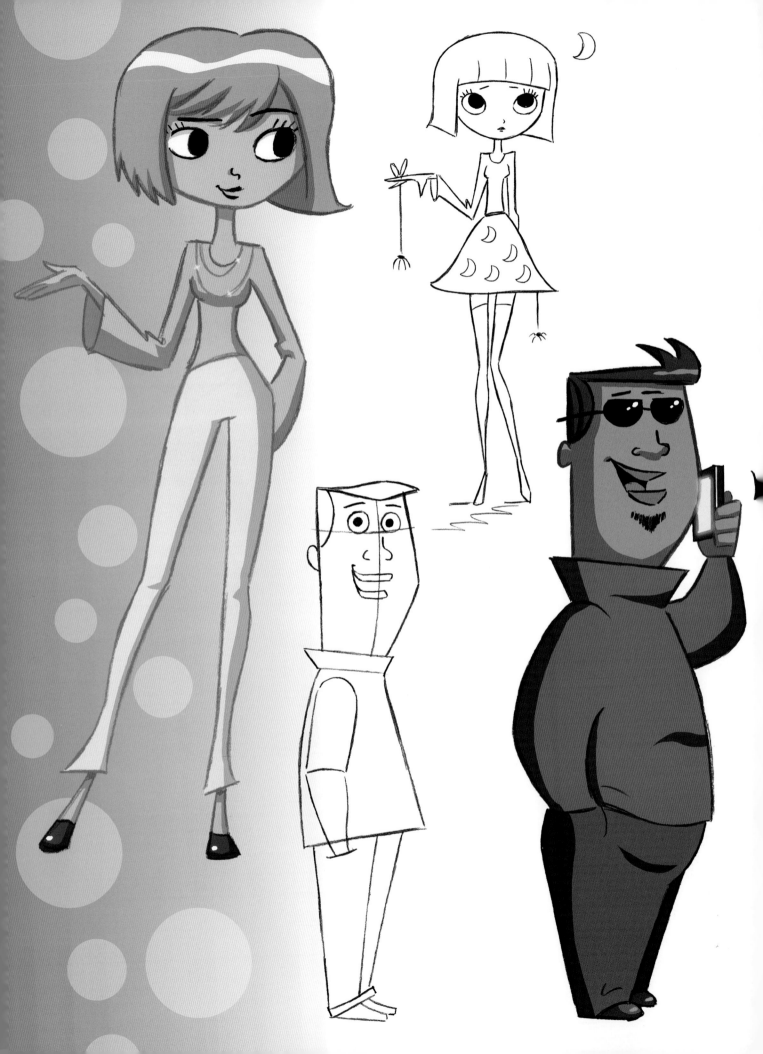

How to Create New Characters from Existing Ones

Many characters are created from scratch. Many others are created from existing characters by making adjustments. I'll guide you through the process and show you how a few simple changes can transform a character. We'll start with small adjustments, and then work our way up to the big changes. I'll provide you with the starting point, and then it will be your turn to try.

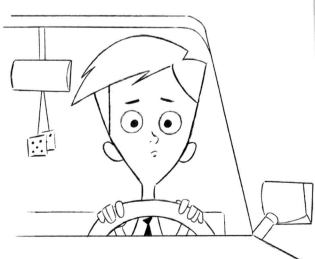

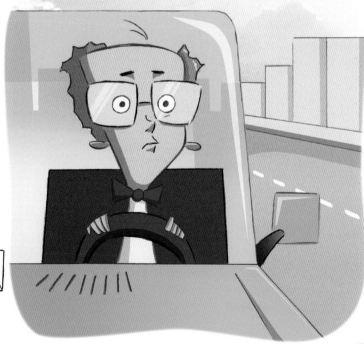

Starting Character: The Good-Natured Guy

Start with the original guy in the white sports shirt. Once that's done, let's reinvent him by making a series of small changes, which will add up to a new character: his annoying younger brother!

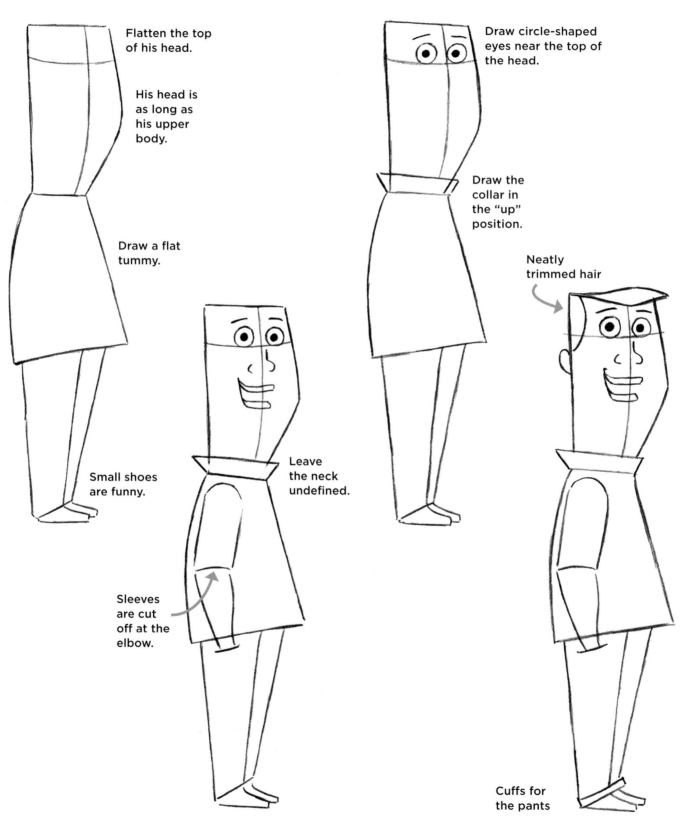

Flatten the top of his head.

His head is as long as his upper body.

Draw a flat tummy.

Small shoes are funny.

Sleeves are cut off at the elbow.

Leave the neck undefined.

Draw circle-shaped eyes near the top of the head.

Draw the collar in the "up" position.

Neatly trimmed hair

Cuffs for the pants

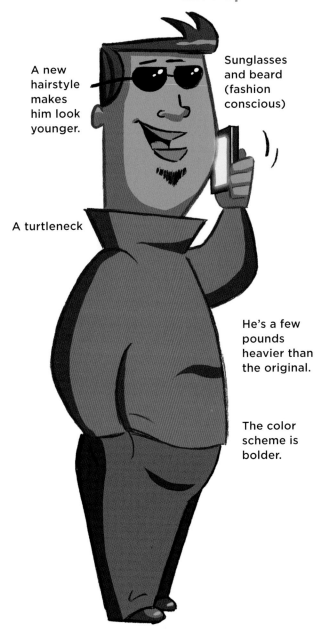

Will he ever get off that cell phone?

A new hairstyle makes him look younger.

Sunglasses and beard (fashion conscious)

A turtleneck

He's a few pounds heavier than the original.

The color scheme is bolder.

ORIGINAL CHARACTER (OLDER BROTHER)

Using our basic character as a starting point, we'll make a few changes. Little by little, a new character begins to emerge.

NEW VERSION (YOUNGER BROTHER)

Because only a few changes have been made, this character still looks similar to the original version. But these changes are sufficient to cast him in the role of the Annoying Younger Brother.

When Good Cartoons Go Bad

The easiest way to draw a "good" character is by making him or her look confused. Only good characters get confused. Evil characters are never confused—they're too busy scheming. Let's start off with a "harmless" kid, then transform him into a "bad" kid.

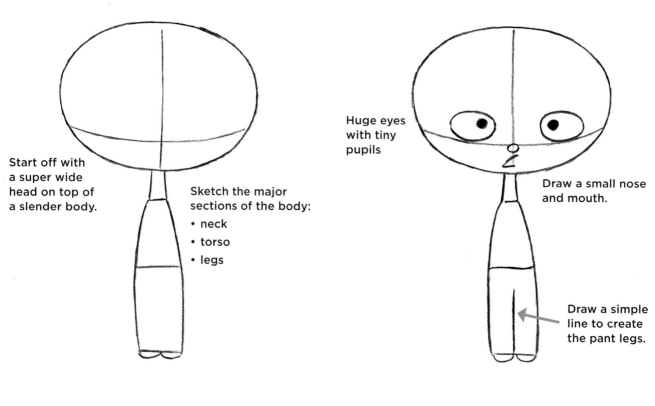

Start off with a super wide head on top of a slender body.

Sketch the major sections of the body:
• neck
• torso
• legs

Huge eyes with tiny pupils

Draw a small nose and mouth.

Draw a simple line to create the pant legs.

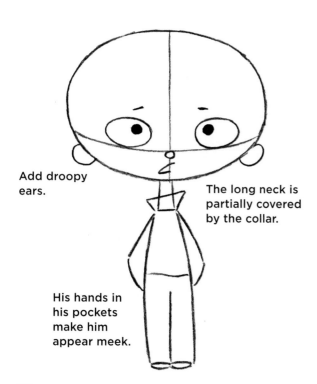

Add droopy ears.

The long neck is partially covered by the collar.

His hands in his pockets make him appear meek.

Draw an unruly head of hair.

72

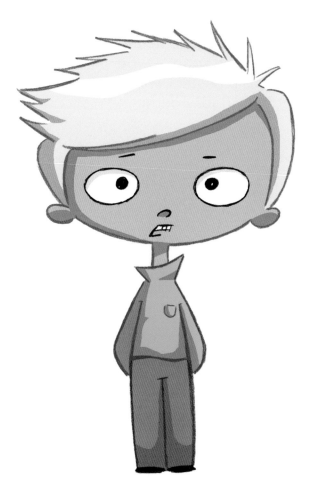

ORIGINAL CHARACTER

I've purposely drawn this character in a neutral pose so that it will easily lend itself to a transformation into another character. If I had drawn him in a specific pose, such as catching a baseball, then I would have been stuck making his alter ego athletic, too.

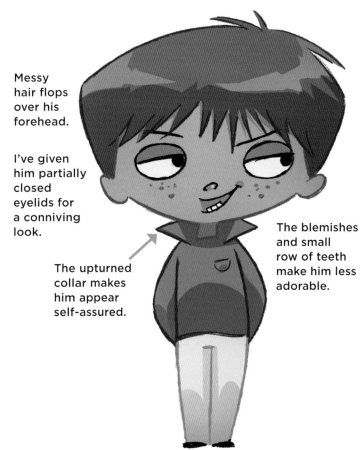

Messy hair flops over his forehead.

I've given him partially closed eyelids for a conniving look.

The upturned collar makes him appear self-assured.

The blemishes and small row of teeth make him less adorable.

NEW VERSION (BAD AND SNEAKY)

Like the characters on the previous spread, he retains some similarity to the original, which makes them both look like they were drawn in the same style.

Creepy and Cute

Let's ratchet up the changes. We'll tweak this original spooky-cute character until it becomes a completely new cute and perky character. The spooky type belongs to a popular genre of animated movies that features monsters, witches, and scary characters. Her cute looks, super-skinny body, and spooky outfit produce an eerily sympathetic character.

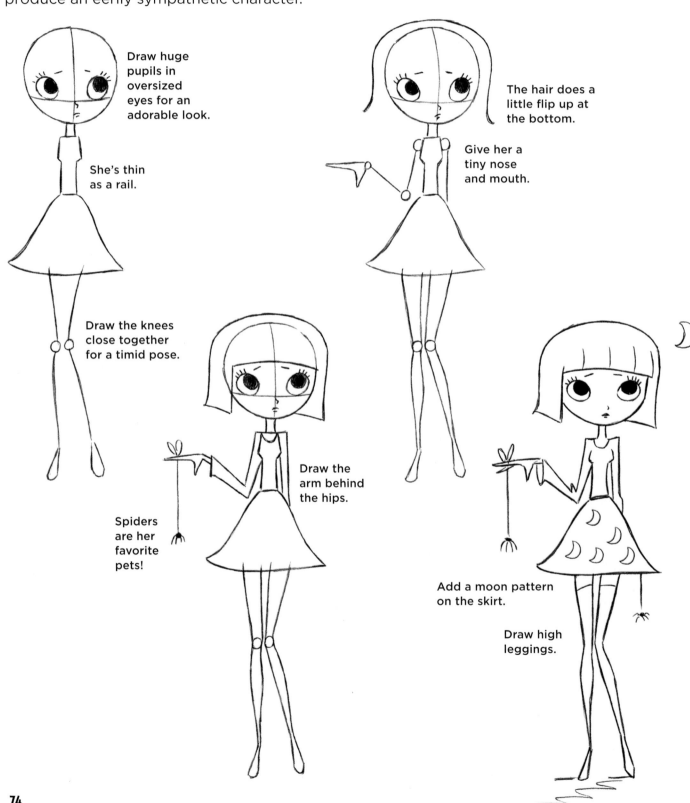

Draw huge pupils in oversized eyes for an adorable look.

She's thin as a rail.

Draw the knees close together for a timid pose.

The hair does a little flip up at the bottom.

Give her a tiny nose and mouth.

Draw the arm behind the hips.

Spiders are her favorite pets!

Add a moon pattern on the skirt.

Draw high leggings.

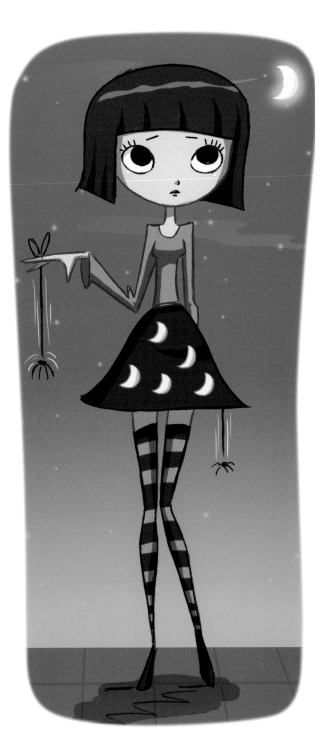

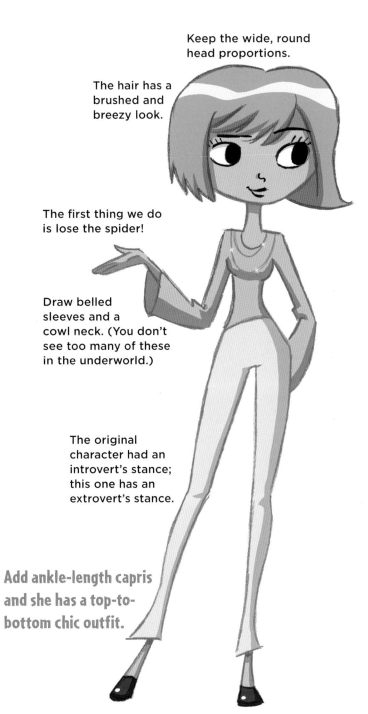

Keep the wide, round head proportions.

The hair has a brushed and breezy look.

The first thing we do is lose the spider!

Draw belled sleeves and a cowl neck. (You don't see too many of these in the underworld.)

The original character had an introvert's stance; this one has an extrovert's stance.

Add ankle-length capris and she has a top-to-bottom chic outfit.

ORIGINAL CHARACTER (CUTE AND CREEPY)

The spooky-cute look can turn vampires and monsters into lovable little fuzz balls. As we begin her transformation into a new character, we'll maintain her basic proportions, but that haircut and outfit have got to go! And we won't stop there. This time, were looking for a complete makeover.

NEW VERSION (CUTE AND PERKY)

Let's leave the undead for a moment and transform the original character into a perky twenty-something. A few strategic tweaks make a big difference.

75

Student Driver and Instructor

Perhaps the easiest way to transform a character's appearance is to significantly change its age. To do this, you've got to add or subtract a lot of years from your original character. For example, a guy who is 20 doesn't look that different from a guy who is 25. But there's a great deal of difference between 15 and 50.

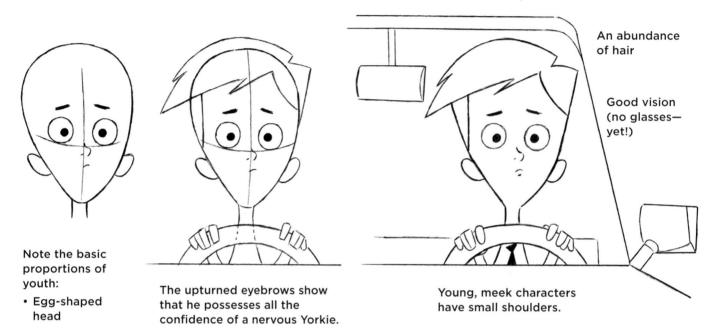

An abundance of hair

Good vision (no glasses— yet!)

Note the basic proportions of youth:

• Egg-shaped head

• Oversized eyes

• Flapping ears

The upturned eyebrows show that he possesses all the confidence of a nervous Yorkie.

Young, meek characters have small shoulders.

If you think he looks anxious now, just wait until he puts the car in drive.

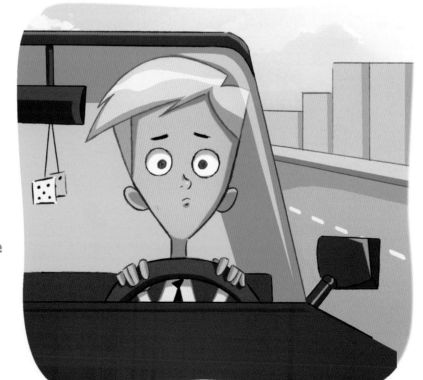

There's a void where his hair used to be.

Oversized glasses

Tiny, horizontal ears

Cheek area widens

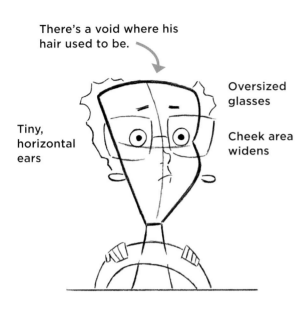

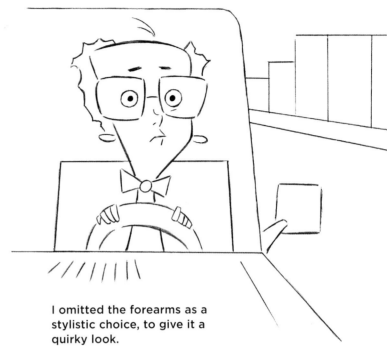

I omitted the forearms as a stylistic choice, to give it a quirky look.

AGE COMPARISON— STUDENT DRIVER VS. DRIVER'S ED INSTRUCTOR

Here are a few things to consider when drawing an older character.

- Older people have flatter foreheads.
- Older characters wear prominent glasses.
- The eyes remain the center of focus for both ages.

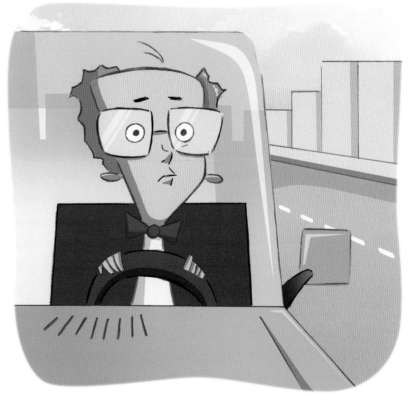

The older you get, the more bow ties appeal to you as a fashion statement.

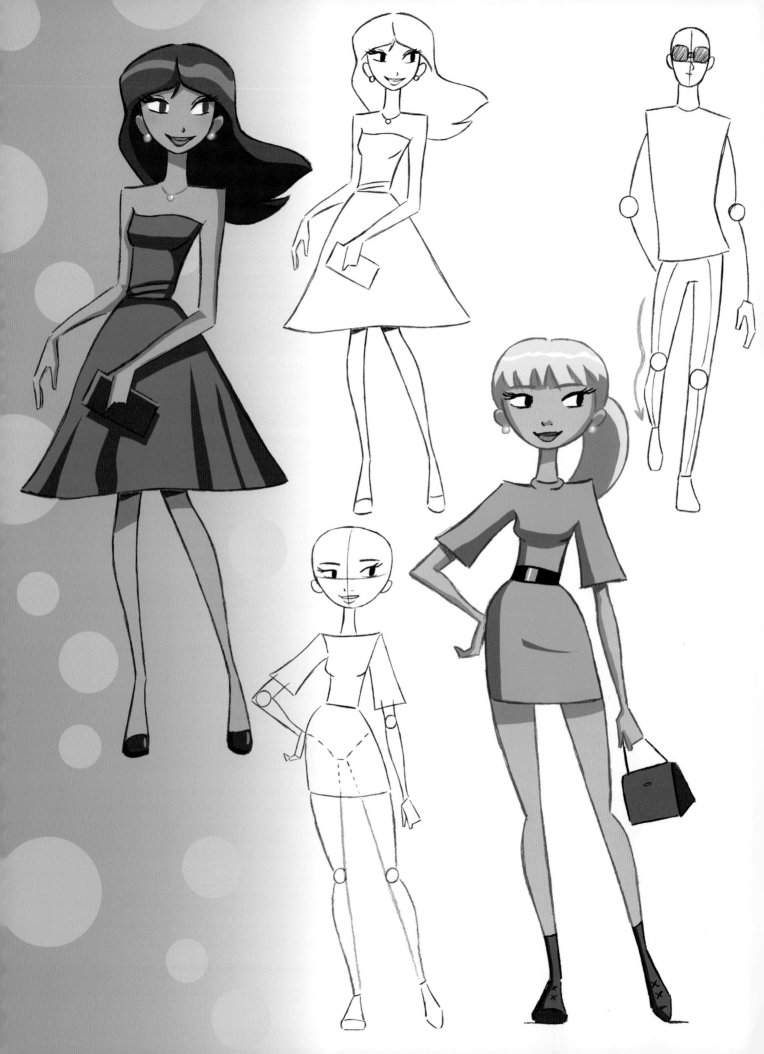

Outfit your Characters in Style

Clothing isn't just an afterthought. An outfit is an important part of a character's design. Fashion can stylize a look to make a cartoon trendy—or funny. It can even help to establish the personality. In this chapter, we'll design some cool outfits using the same step-by-step methods from previous chapters.

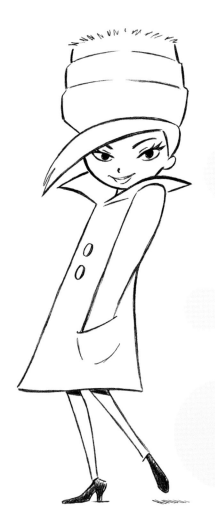

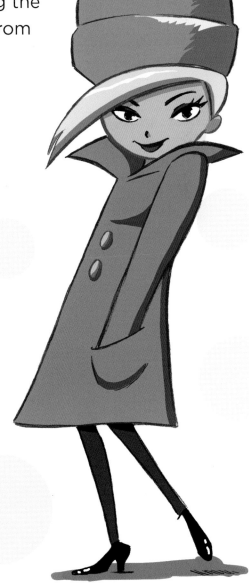

Fuzzy Hat and Winter Coat

Some people find winter clothes clumsy-looking. But cartoonists know how to turn up the style. Winter outfits are easy to draw because they're based on a single shape.

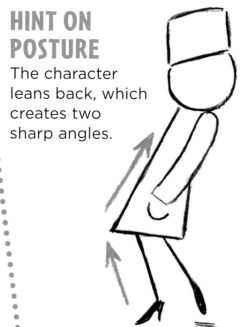

HINT ON POSTURE

The character leans back, which creates two sharp angles.

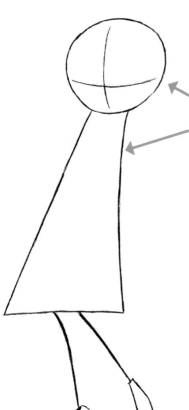

This is a simple construction: a basic head shape on top of a basic body shape.

- Head shaped like a globe
- Body shaped like a triangle with the top chopped off

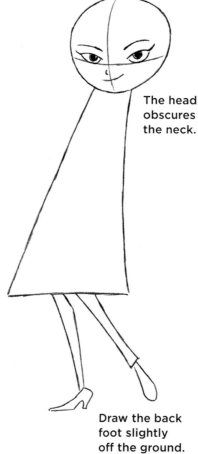

The head obscures the neck.

Draw the back foot slightly off the ground.

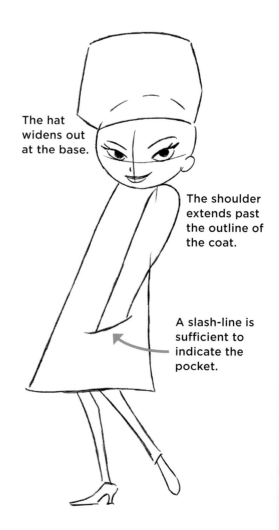

The hat widens out at the base.

The shoulder extends past the outline of the coat.

A slash-line is sufficient to indicate the pocket.

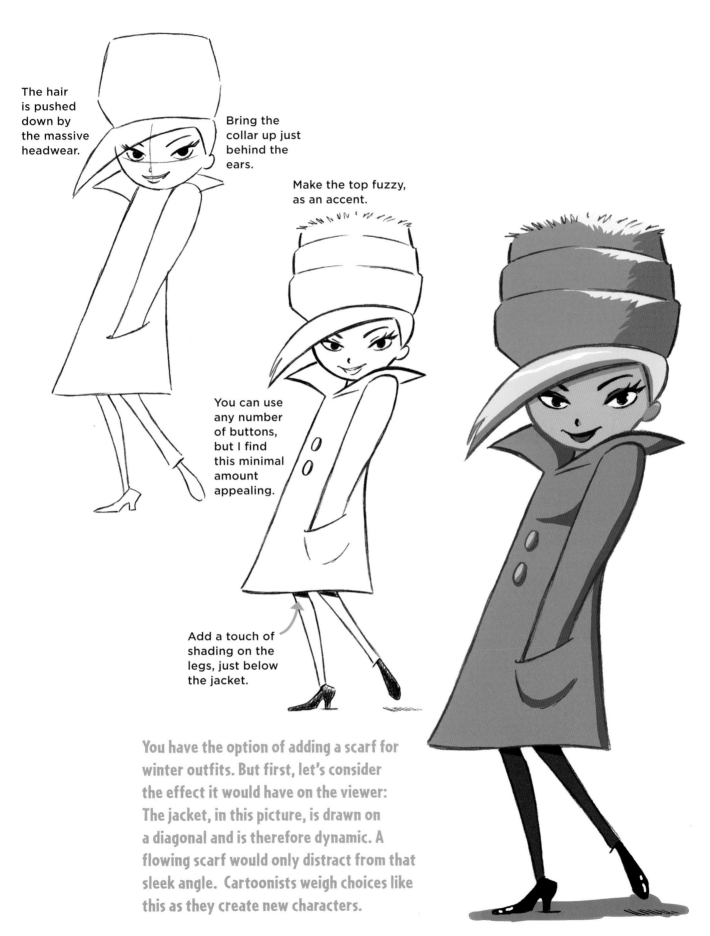

The hair is pushed down by the massive headwear.

Bring the collar up just behind the ears.

Make the top fuzzy, as an accent.

You can use any number of buttons, but I find this minimal amount appealing.

Add a touch of shading on the legs, just below the jacket.

You have the option of adding a scarf for winter outfits. But first, let's consider the effect it would have on the viewer: The jacket, in this picture, is drawn on a diagonal and is therefore dynamic. A flowing scarf would only distract from that sleek angle. Cartoonists weigh choices like this as they create new characters.

Short Dress

This stylish dress has a high collar and a high hemline. The basic form, on which the dress is built, is a simple shape. The ankle boots add a retro look to the outfit.

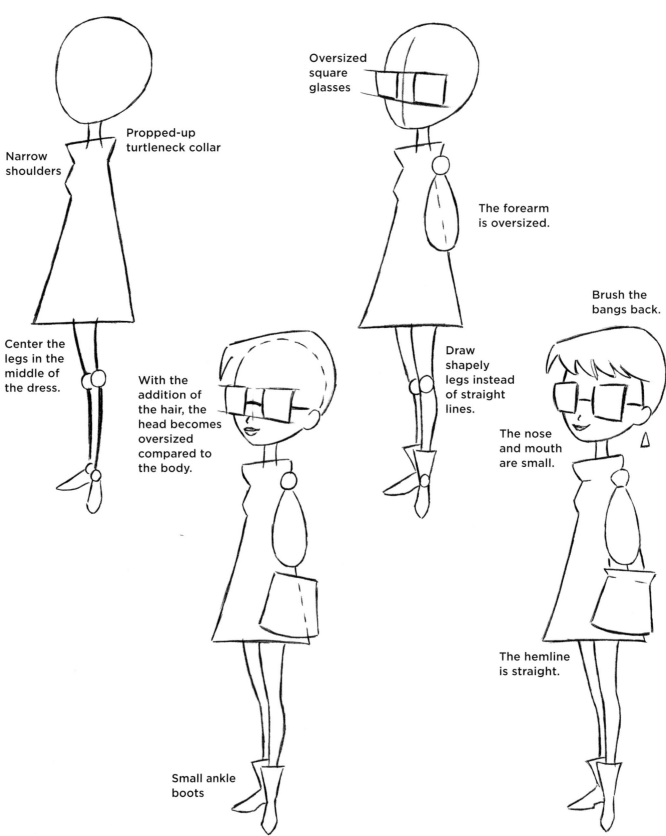

Narrow shoulders

Propped-up turtleneck collar

Center the legs in the middle of the dress.

With the addition of the hair, the head becomes oversized compared to the body.

Small ankle boots

Oversized square glasses

The forearm is oversized.

Draw shapely legs instead of straight lines.

Brush the bangs back.

The nose and mouth are small.

The hemline is straight.

Sleeveless Dress

Here's another example of how a simple clothing item can be stylish. To create the look, raise that waistband to just under the chest. This creates the illusion that her legs are longer than they actually are.

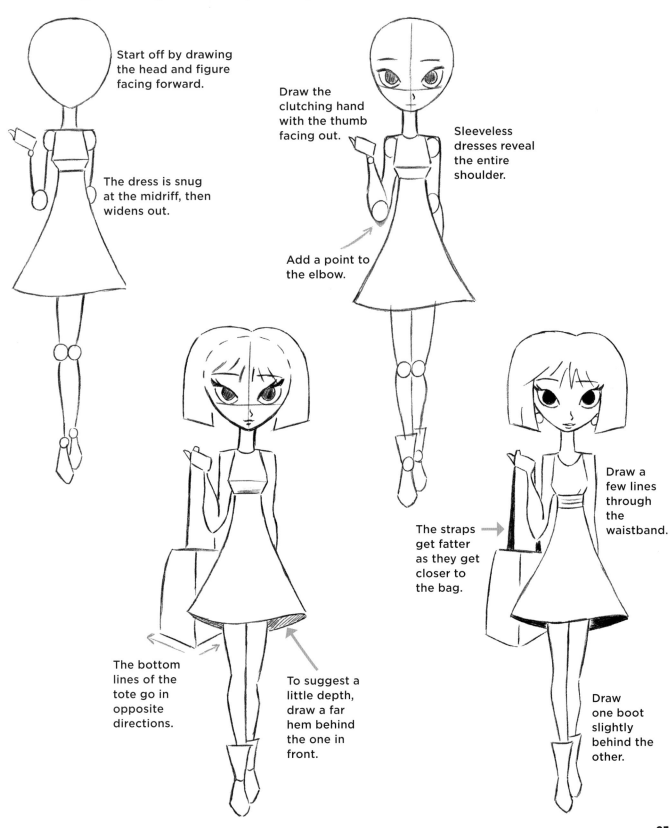

Start off by drawing the head and figure facing forward.

The dress is snug at the midriff, then widens out.

Draw the clutching hand with the thumb facing out.

Sleeveless dresses reveal the entire shoulder.

Add a point to the elbow.

The bottom lines of the tote go in opposite directions.

To suggest a little depth, draw a far hem behind the one in front.

The straps get fatter as they get closer to the bag.

Draw a few lines through the waistband.

Draw one boot slightly behind the other.

Strapless Dress

Strapless dresses are versatile and are worn by many different character types. For example, they work as well on a celebrity walking in front of the cameras as they do on a teenager tripping all over herself as she attends her prom.

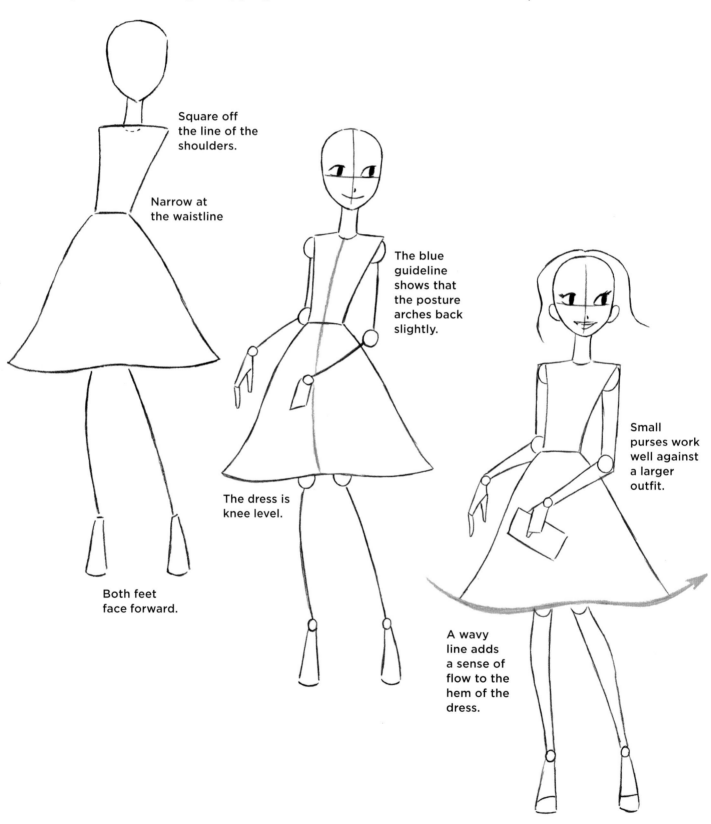

Square off the line of the shoulders.

Narrow at the waistline

Both feet face forward.

The blue guideline shows that the posture arches back slightly.

The dress is knee level.

Small purses work well against a larger outfit.

A wavy line adds a sense of flow to the hem of the dress.

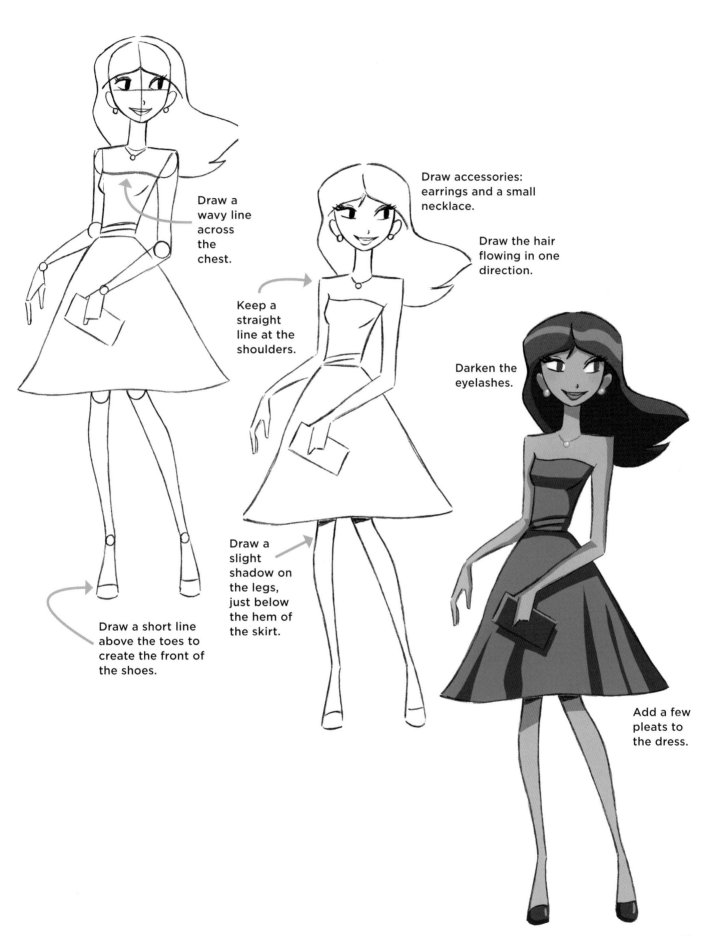

Draw a wavy line across the chest.

Draw a short line above the toes to create the front of the shoes.

Draw accessories: earrings and a small necklace.

Draw the hair flowing in one direction.

Keep a straight line at the shoulders.

Darken the eyelashes.

Draw a slight shadow on the legs, just below the hem of the skirt.

Add a few pleats to the dress.

Dress with Sleeves

The cut of this outfit emphasizes the shoulders and hips. Because this dress accentuates the figure, we'll rough out the hips and upper body first. If the drawing of the figure looks solid, the dress will too.

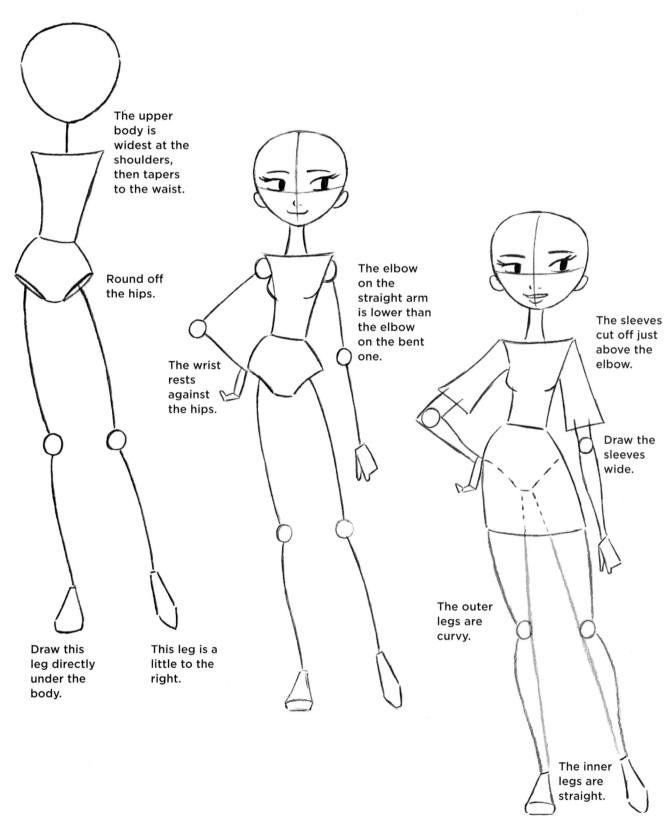

The upper body is widest at the shoulders, then tapers to the waist.

Round off the hips.

The wrist rests against the hips.

The elbow on the straight arm is lower than the elbow on the bent one.

Draw this leg directly under the body.

This leg is a little to the right.

The sleeves cut off just above the elbow.

Draw the sleeves wide.

The outer legs are curvy.

The inner legs are straight.

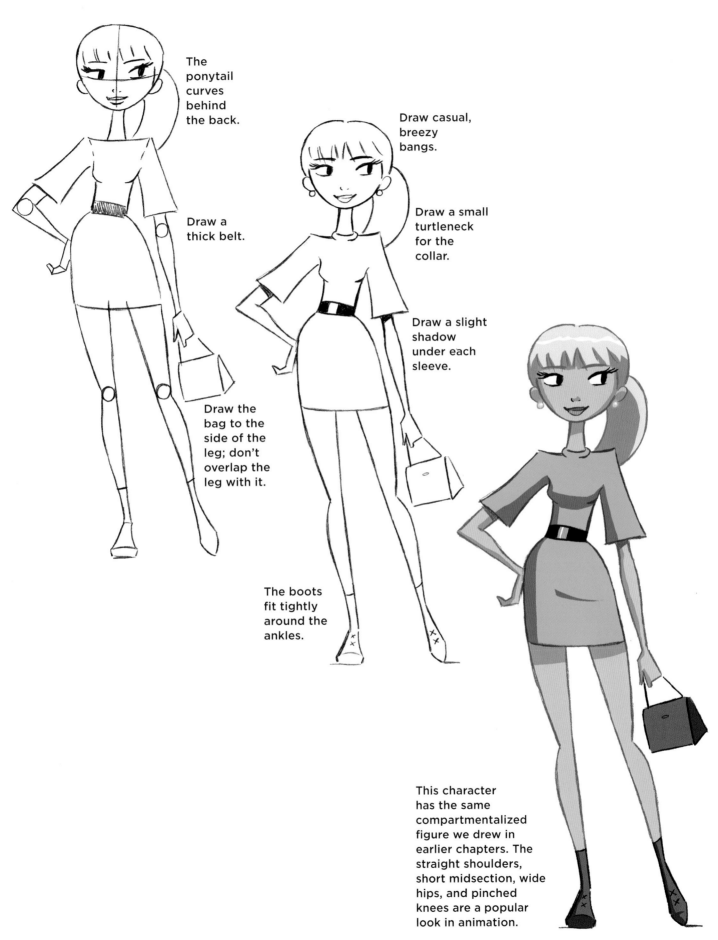

The ponytail curves behind the back.

Draw a thick belt.

Draw casual, breezy bangs.

Draw a small turtleneck for the collar.

Draw a slight shadow under each sleeve.

Draw the bag to the side of the leg; don't overlap the leg with it.

The boots fit tightly around the ankles.

This character has the same compartmentalized figure we drew in earlier chapters. The straight shoulders, short midsection, wide hips, and pinched knees are a popular look in animation.

Trendy Guy

Even casual outfits look fashionable if they're drawn to fit a sporty frame. This means the construction of the body is very important to the design of an outfit. Let's take an extra step to focus on it.

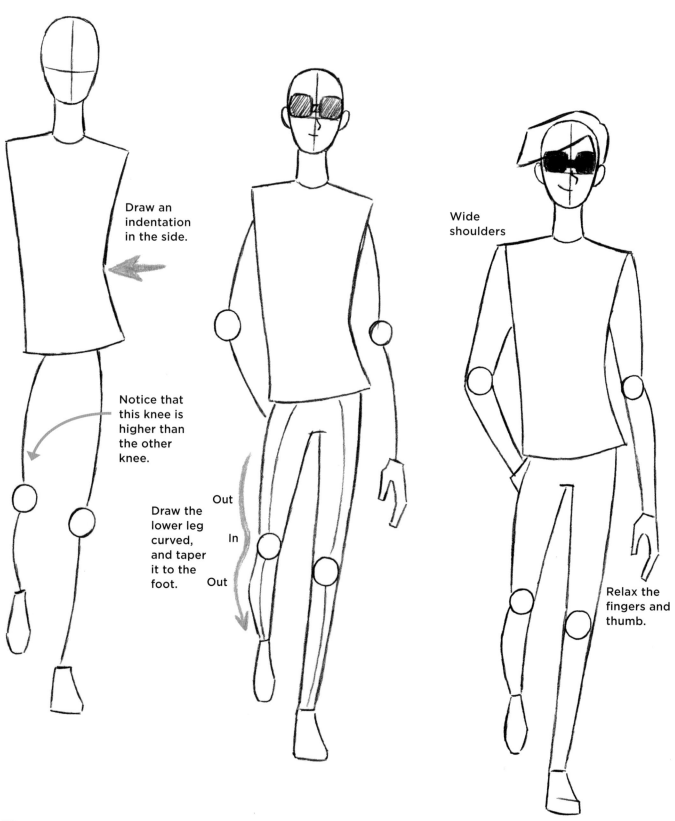

Draw an indentation in the side.

Notice that this knee is higher than the other knee.

Draw the lower leg curved, and taper it to the foot.

Out

In

Out

Wide shoulders

Relax the fingers and thumb.

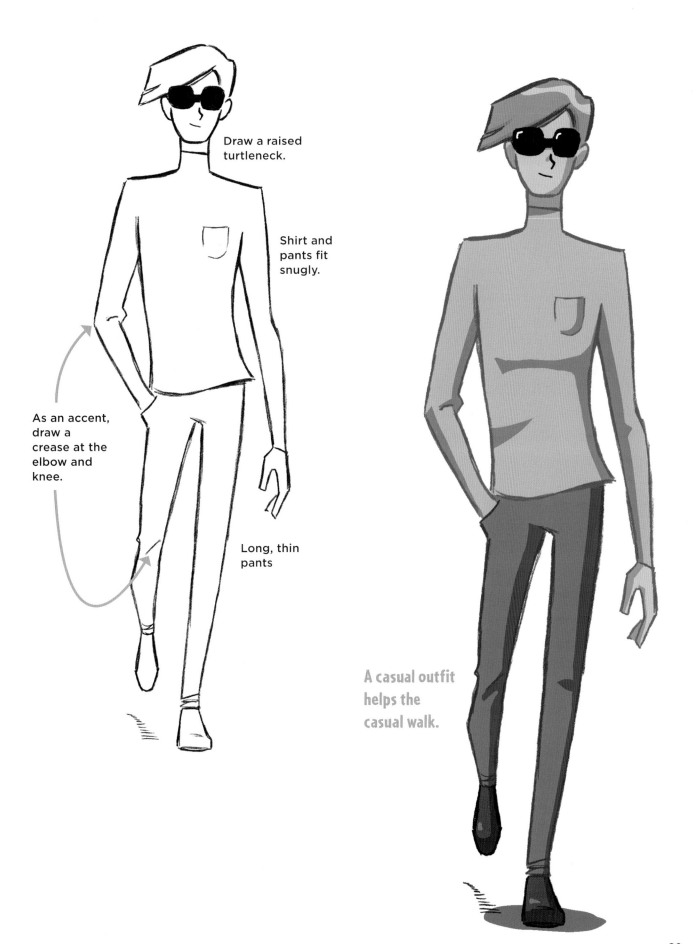

Draw a raised turtleneck.

Shirt and pants fit snugly.

As an accent, draw a crease at the elbow and knee.

Long, thin pants

A casual outfit helps the casual walk.

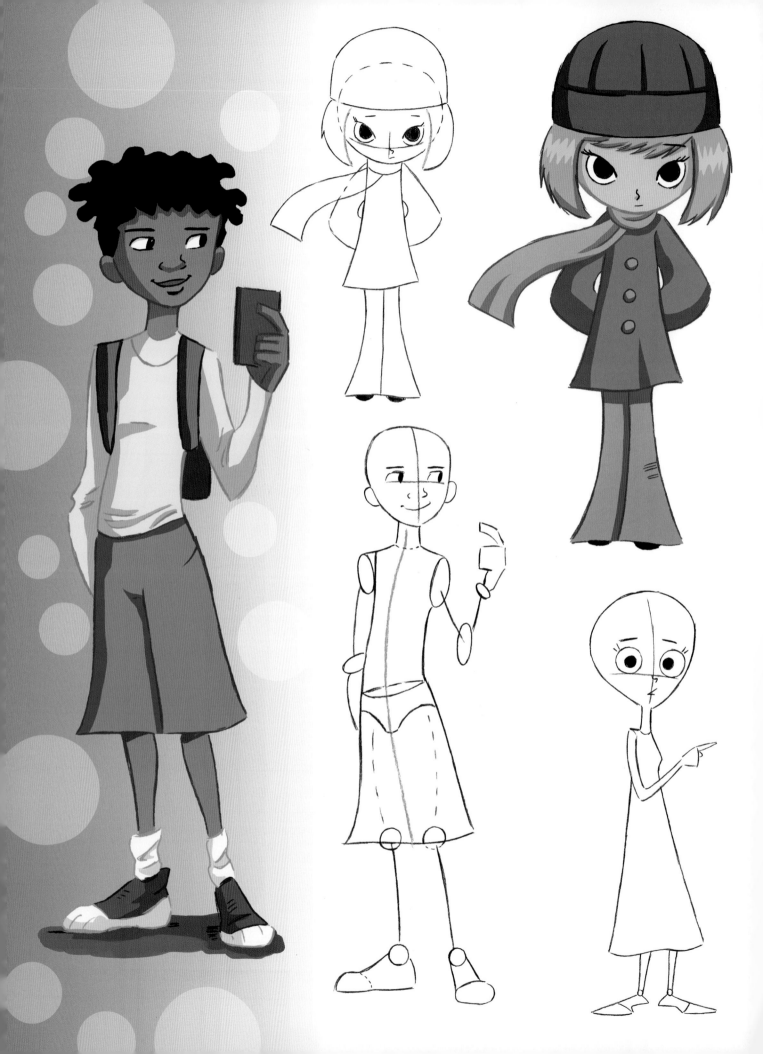

Draw Even More Characters, Step-By-Step!

In this section, the characters get to steer the boat! Previously, each chapter demonstrated a single concept. This chapter provides a variety of characters, each of which requires a different approach. One might use exaggeration, while another might utilize a certain outfit or pose. Giving a character what it needs so that it becomes what it wants to be is the essence of character design.

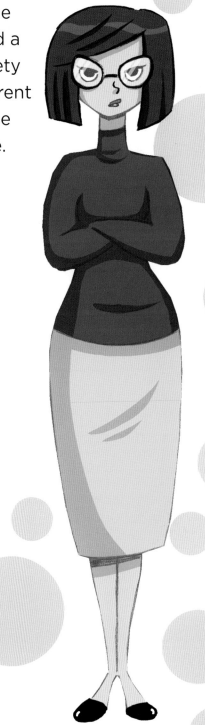

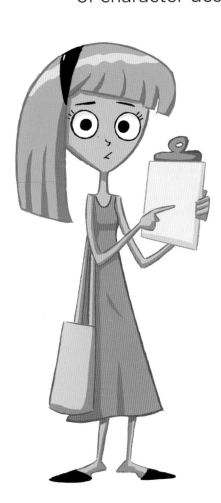

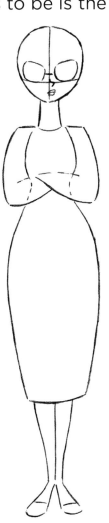

Popular High School Teen

In addition to drawing an engaging smile, we'll also draw an important prop: a cell phone that never cools off. He'll pause every now and then to read his latest 147 messages. This character is in his mid-teenage years, which means he has a balanced look—not skinny, but not built up either.

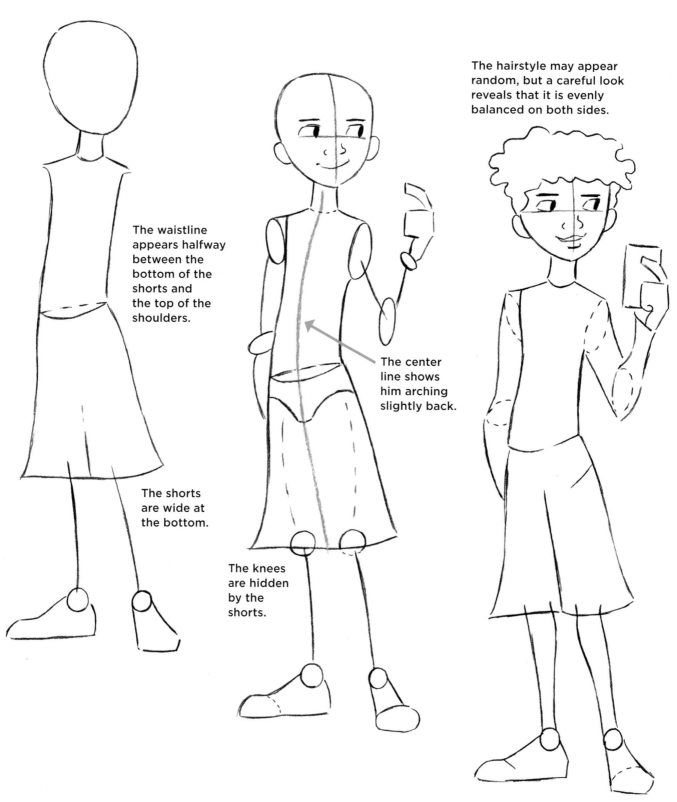

The hairstyle may appear random, but a careful look reveals that it is evenly balanced on both sides.

The waistline appears halfway between the bottom of the shorts and the top of the shoulders.

The center line shows him arching slightly back.

The shorts are wide at the bottom.

The knees are hidden by the shorts.

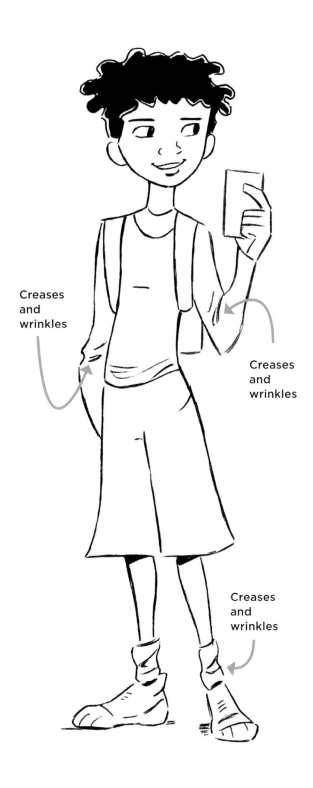

Creases and wrinkles

Creases and wrinkles

Creases and wrinkles

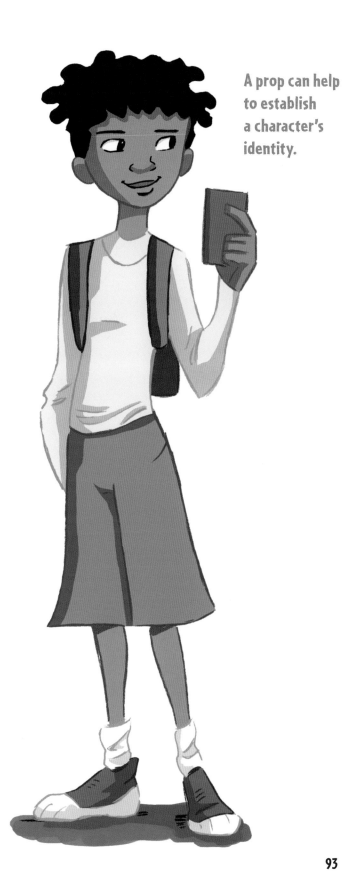

A prop can help to establish a character's identity.

Crusader for a Cause

She's saving the world, one signature at a time. You may be tempted to give her two minutes of your time, just to be polite. But those two minutes will turn into a grueling two-hour plea for the endangered Norwegian pepper snake.

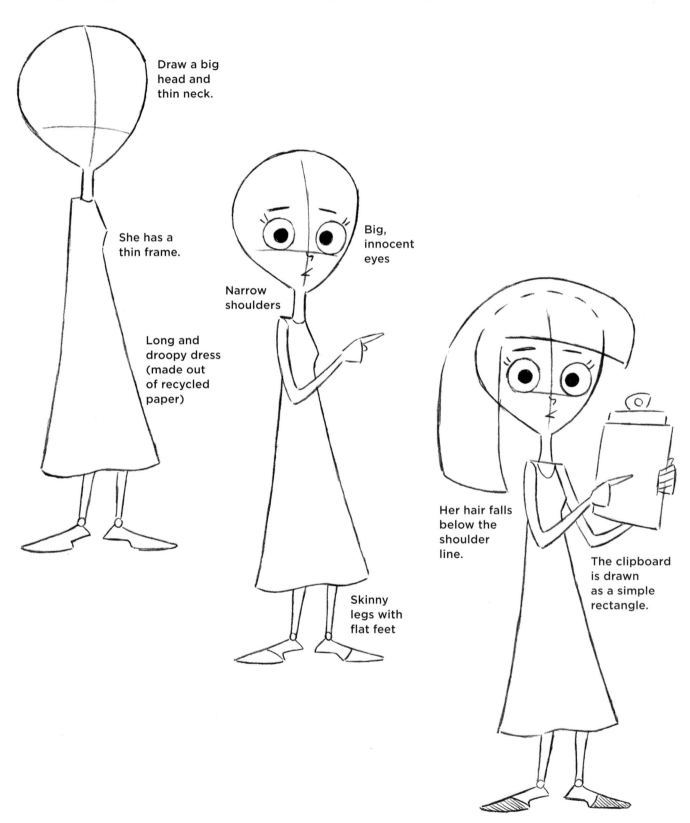

Draw a big head and thin neck.

She has a thin frame.

Long and droopy dress (made out of recycled paper)

Big, innocent eyes

Narrow shoulders

Skinny legs with flat feet

Her hair falls below the shoulder line.

The clipboard is drawn as a simple rectangle.

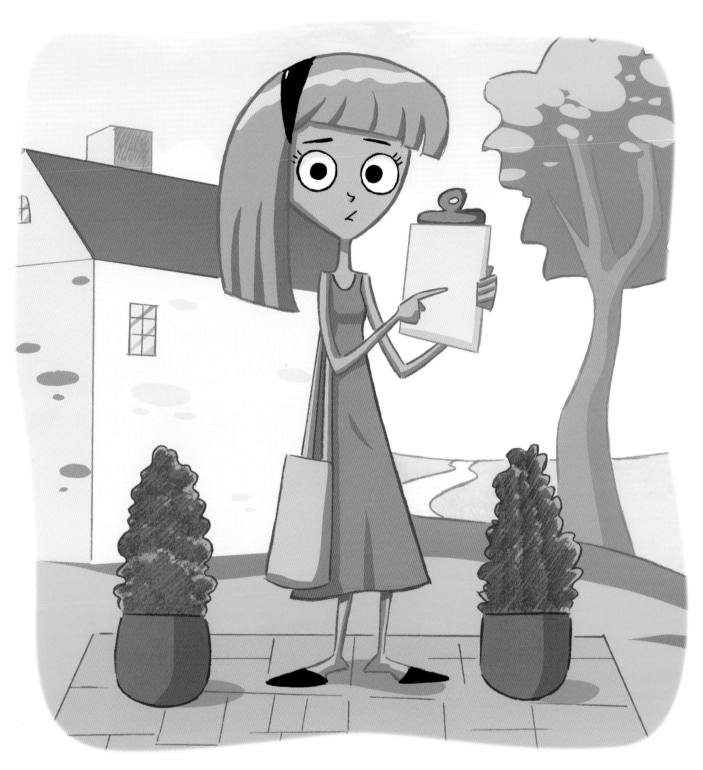

When drawing a scene, you have to prioritize the elements. In this scenario, her bright eyes and clipboard draw the viewer's attention. In the background, the two urns and the wide, stone step are the prominent features.

The Classic Animation-Style Kid

The ages 10-12 are especially popular for kids in animated movies. These youngsters typically display boundless energy, optimism, springy bodies, and big emotions. This character's pose has been drawn to match his expression.

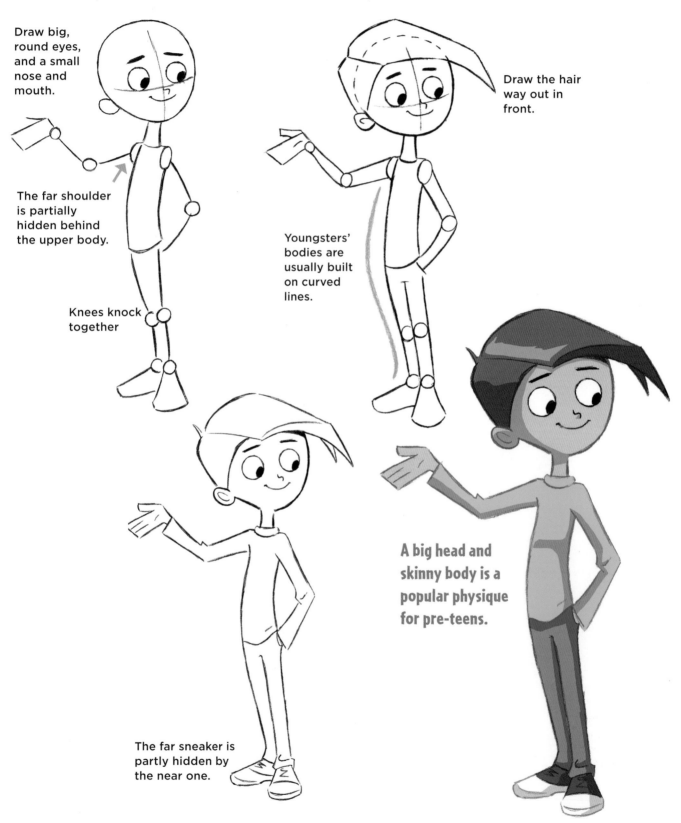

Draw big, round eyes, and a small nose and mouth.

The far shoulder is partially hidden behind the upper body.

Knees knock together

Draw the hair way out in front.

Youngsters' bodies are usually built on curved lines.

The far sneaker is partly hidden by the near one.

A big head and skinny body is a popular physique for pre-teens.

Selfie Mania

She takes pictures of herself when she's with friends, on the train, and at the gym. Of course, let's not forget the requisite snapshot of what she had for lunch—who'd want to miss that gem? Ratchet up the obsession and you've got a funny character.

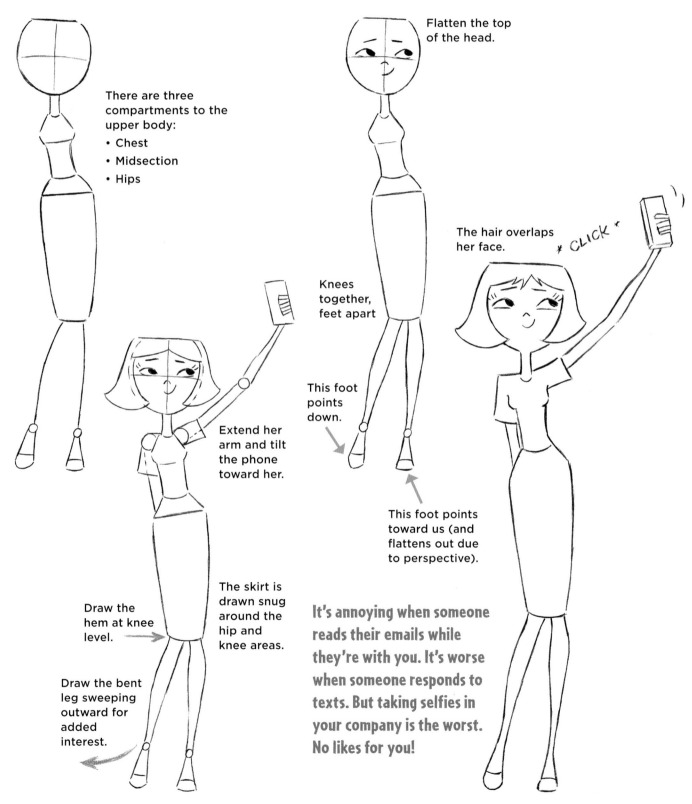

There are three compartments to the upper body:
• Chest
• Midsection
• Hips

Extend her arm and tilt the phone toward her.

Draw the hem at knee level.

The skirt is drawn snug around the hip and knee areas.

Draw the bent leg sweeping outward for added interest.

Flatten the top of the head.

Knees together, feet apart

This foot points down.

This foot points toward us (and flattens out due to perspective).

The hair overlaps her face.

* CLICK *

It's annoying when someone reads their emails while they're with you. It's worse when someone responds to texts. But taking selfies in your company is the worst. No likes for you!

97

The Classroom

Ah, this brings back fond memories—for me, not the teacher. You might assume that being bombarded by a few dozen paper airplanes would get a teacher to lighten up. You would be wrong.

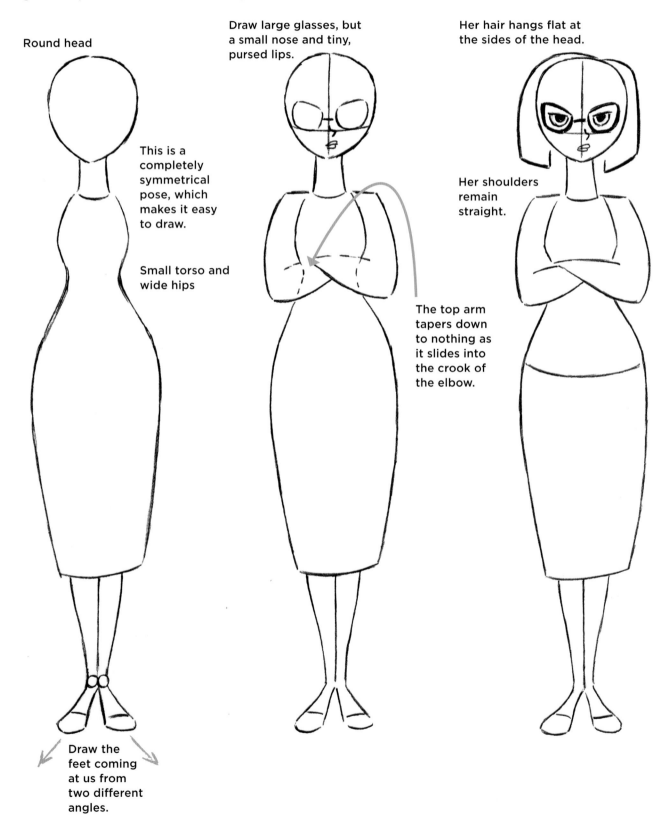

Round head

Draw large glasses, but a small nose and tiny, pursed lips.

Her hair hangs flat at the sides of the head.

This is a completely symmetrical pose, which makes it easy to draw.

Small torso and wide hips

Her shoulders remain straight.

The top arm tapers down to nothing as it slides into the crook of the elbow.

Draw the feet coming at us from two different angles.

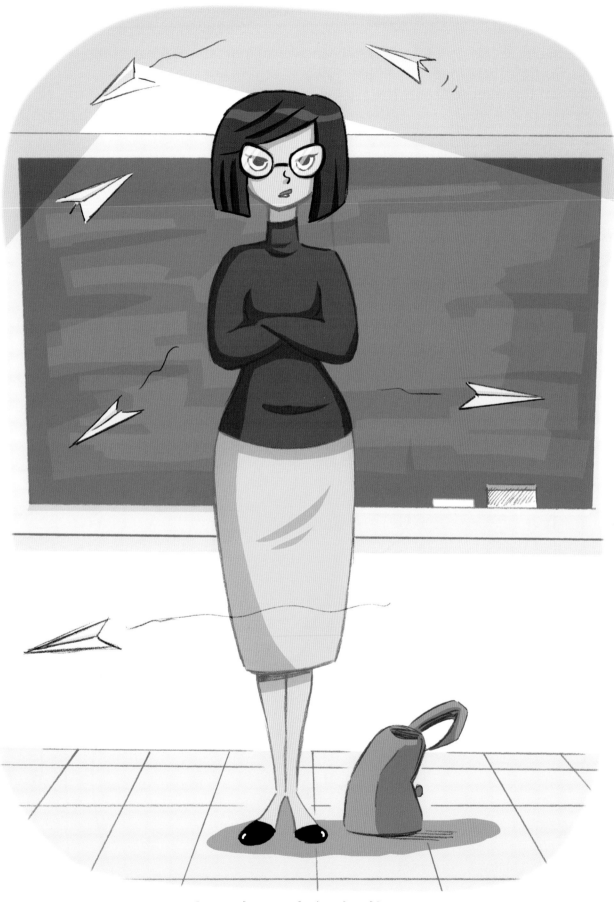

Guess who gets the last laugh?

The Loner

Everything about this character's appearance is an indication of her frame of mind. Some of her "loner" traits are obvious, others are subtle. We'll weave them together to create the typical high school introvert.

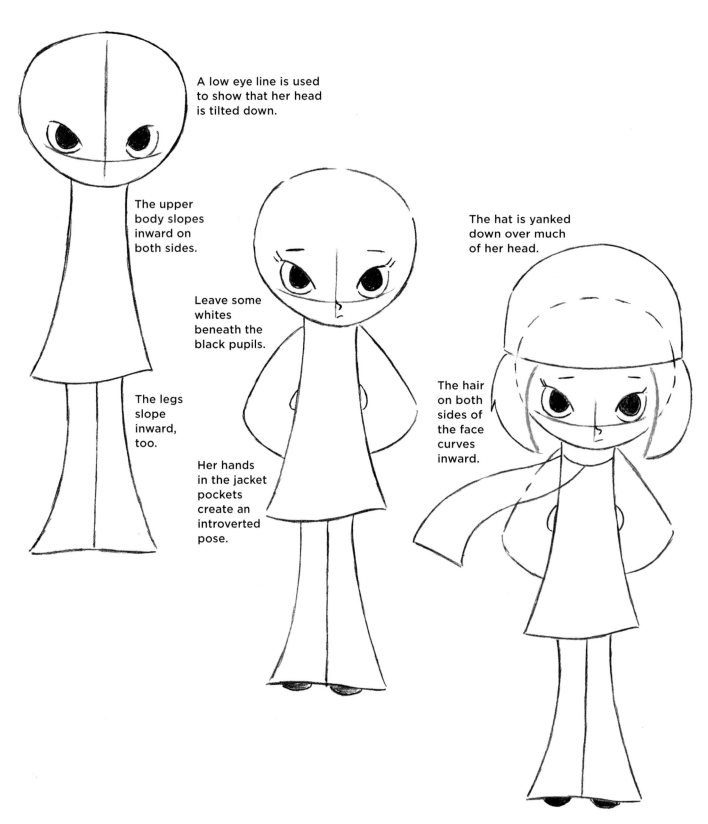

A low eye line is used to show that her head is tilted down.

The upper body slopes inward on both sides.

Leave some whites beneath the black pupils.

The legs slope inward, too.

Her hands in the jacket pockets create an introverted pose.

The hat is yanked down over much of her head.

The hair on both sides of the face curves inward.

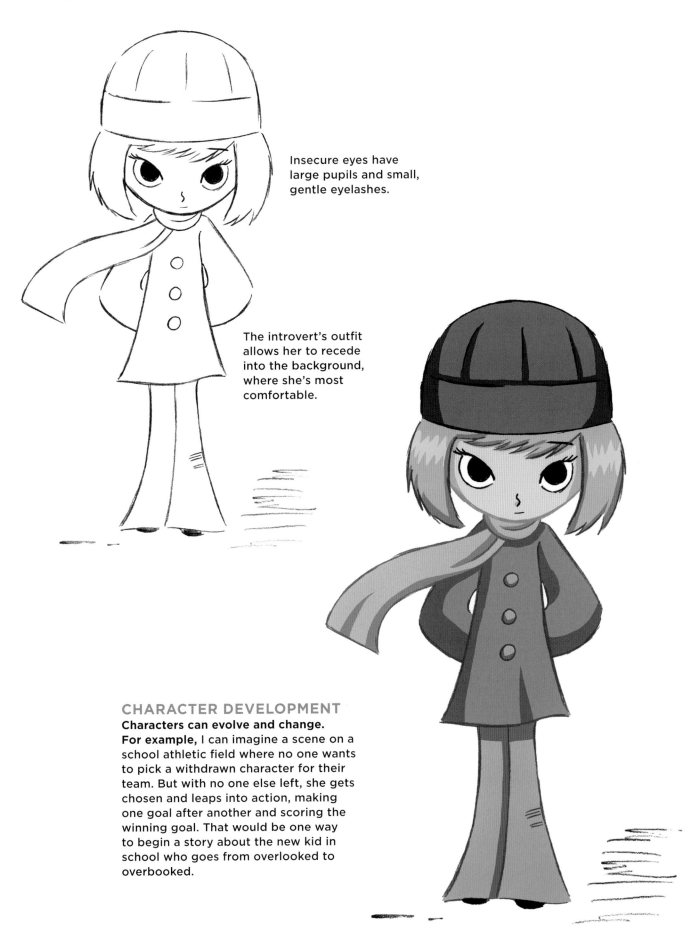

Insecure eyes have large pupils and small, gentle eyelashes.

The introvert's outfit allows her to recede into the background, where she's most comfortable.

CHARACTER DEVELOPMENT

Characters can evolve and change. For example, I can imagine a scene on a school athletic field where no one wants to pick a withdrawn character for their team. But with no one else left, she gets chosen and leaps into action, making one goal after another and scoring the winning goal. That would be one way to begin a story about the new kid in school who goes from overlooked to overbooked.

Super Dweeb

Some characters try hard. And the harder they try, the less they succeed. Take the ever-present Super Dweeb. Not content to be known as the only teen who didn't receive an invitation to his own party, Super Dweeb has decided to get the trendiest clothes and haircut to transform himself into the coolest kid in school. Um, okay. Sure.

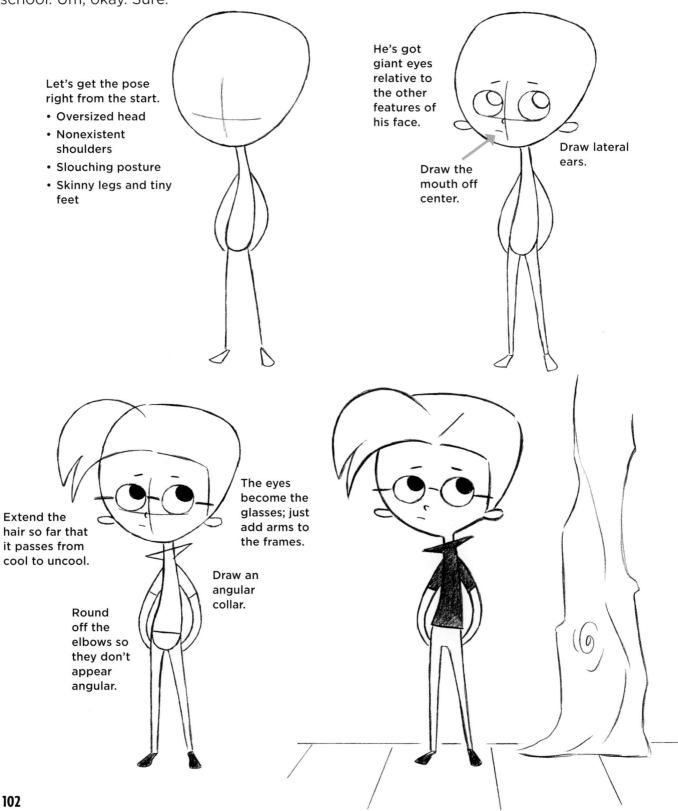

Let's get the pose right from the start.
- Oversized head
- Nonexistent shoulders
- Slouching posture
- Skinny legs and tiny feet

He's got giant eyes relative to the other features of his face.

Draw the mouth off center.

Draw lateral ears.

Extend the hair so far that it passes from cool to uncool.

Round off the elbows so they don't appear angular.

The eyes become the glasses; just add arms to the frames.

Draw an angular collar.

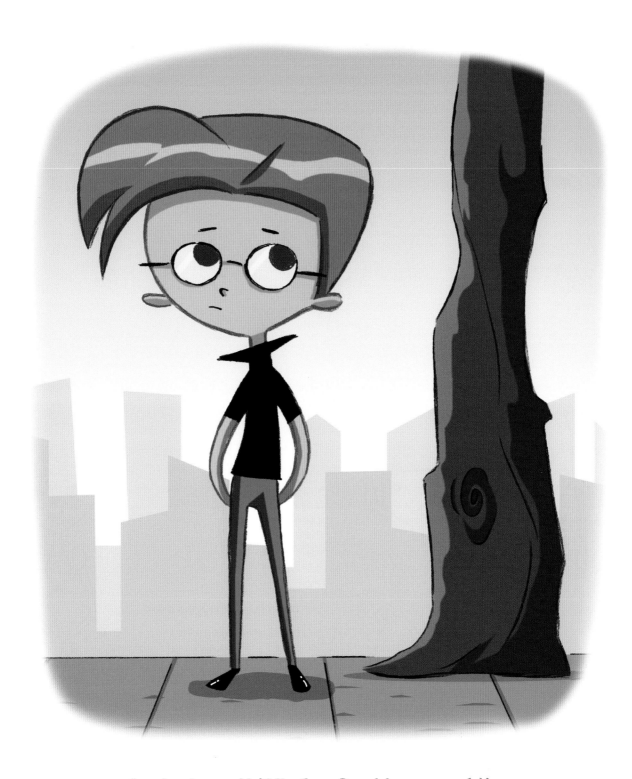

So, what do you think? Has Super Dweeb been successful in transforming himself into the popular kid on campus? I hope not. He's too much fun as an insecure character.

Cute and Quirky

This pretty character has a cute look and pose. To add a little more interest, I added a gothic influence. This odd amalgam makes the viewer wonder what she's about. If you can get your reader to think about your character, you're on the right track.

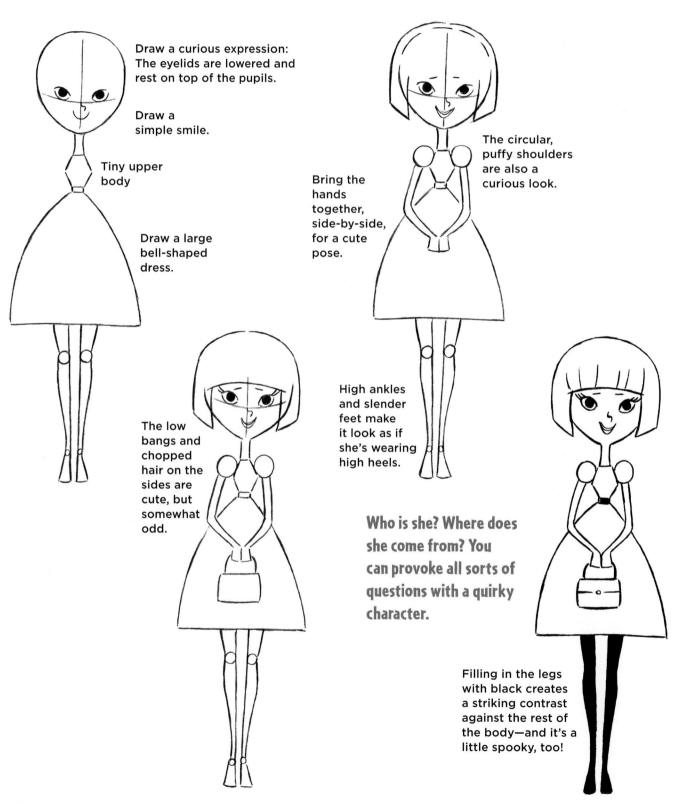

Draw a curious expression: The eyelids are lowered and rest on top of the pupils.

Draw a simple smile.

Tiny upper body

Draw a large bell-shaped dress.

The circular, puffy shoulders are also a curious look.

Bring the hands together, side-by-side, for a cute pose.

The low bangs and chopped hair on the sides are cute, but somewhat odd.

High ankles and slender feet make it look as if she's wearing high heels.

Who is she? Where does she come from? You can provoke all sorts of questions with a quirky character.

Filling in the legs with black creates a striking contrast against the rest of the body—and it's a little spooky, too!

The "Normal" Character

In animated feature films, there's usually one character that rises above the craziness. This character serves as the window through which the audience views the story. She provides an island of sanity and perspective, so that the audience isn't overwhelmed by zaniness.

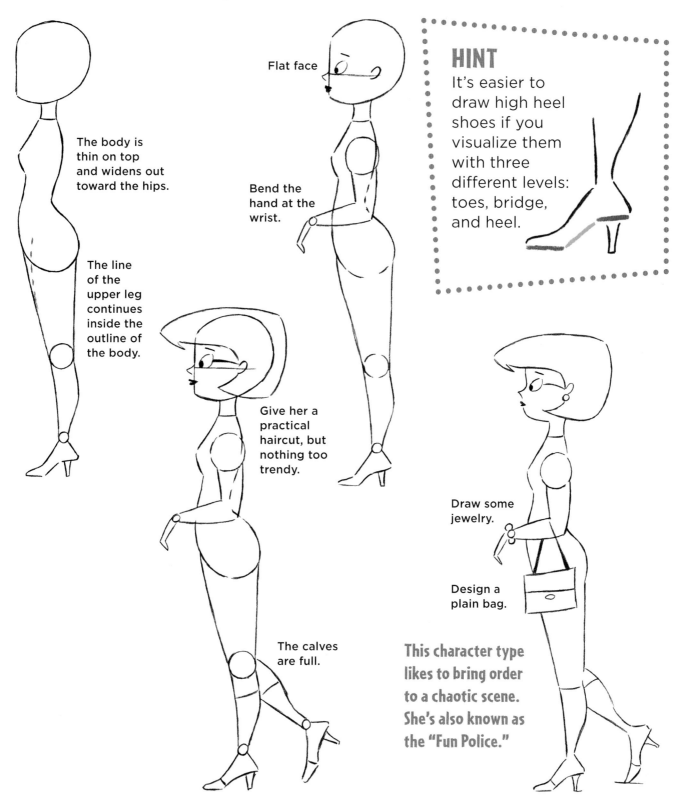

The body is thin on top and widens out toward the hips.

The line of the upper leg continues inside the outline of the body.

Flat face

Bend the hand at the wrist.

HINT
It's easier to draw high heel shoes if you visualize them with three different levels: toes, bridge, and heel.

Give her a practical haircut, but nothing too trendy.

The calves are full.

Draw some jewelry.

Design a plain bag.

This character type likes to bring order to a chaotic scene. She's also known as the "Fun Police."

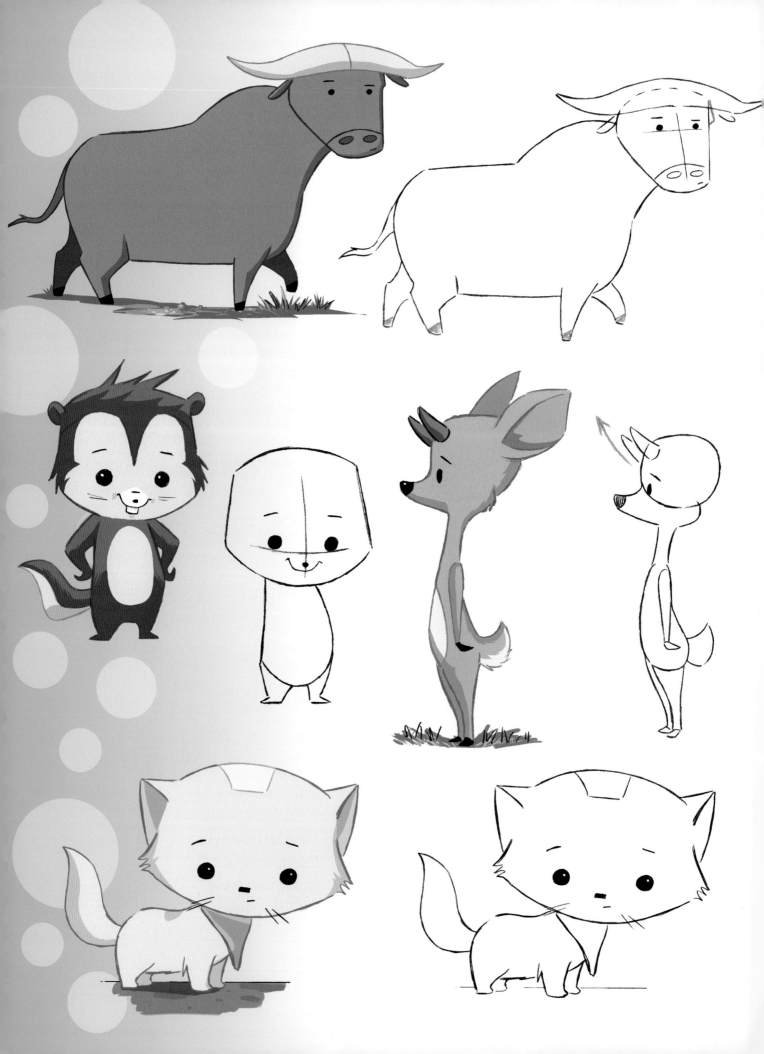

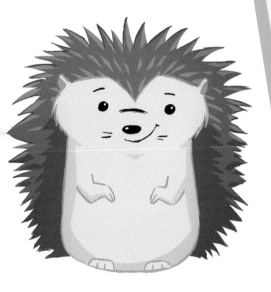

Super-Simple Cartoon Animals

Now I'm going to show you how to draw a super-simple style of cartooning. Animals are a good subject because button-style eyes work well with most species, and they are expressive. Drawn realistically, or even semi-realistically, their construction can get complicated. But this style simplifies it. All the extraneous details have been eliminated, allowing the personality of each animal to shine through. We'll focus on the three essentials: The features of the face, the defining features of the body, and posture. With this approach, you can begin to draw all kinds of animals that you once thought were difficult.

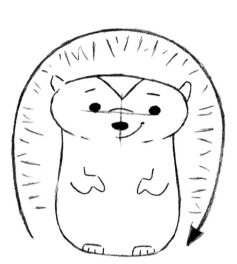

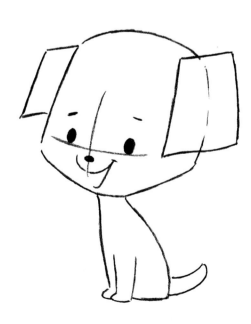

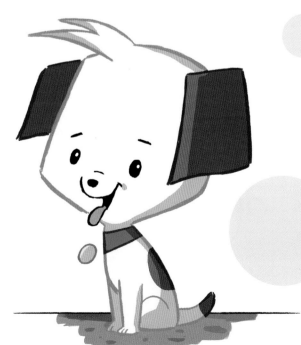

Super-Simple Puppy

SIMPLE PROPORTIONS: Because it's a puppy, we're going to exaggerate the size of its head and minimize the size of its body.

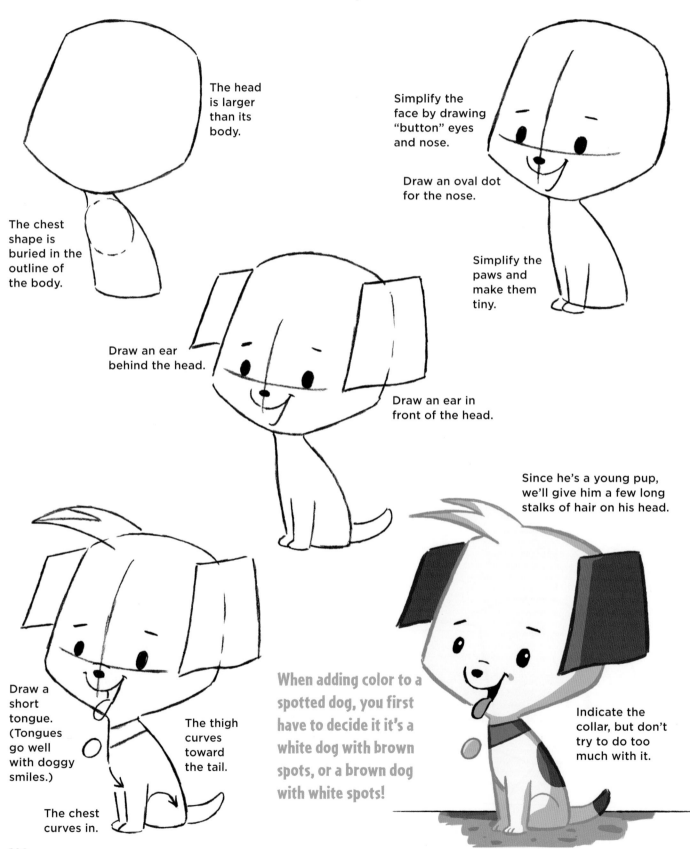

The head is larger than its body.

The chest shape is buried in the outline of the body.

Simplify the face by drawing "button" eyes and nose.

Draw an oval dot for the nose.

Simplify the paws and make them tiny.

Draw an ear behind the head.

Draw an ear in front of the head.

Since he's a young pup, we'll give him a few long stalks of hair on his head.

Draw a short tongue. (Tongues go well with doggy smiles.)

The thigh curves toward the tail.

The chest curves in.

When adding color to a spotted dog, you first have to decide it it's a white dog with brown spots, or a brown dog with white spots!

Indicate the collar, but don't try to do too much with it.

Super-Simple Hound Dog

Hounds have a prominent feature: flews. These are the puffy pads on either side of the nose, which add width to a dog's face. Let's use a lot of rounded lines to infuse this pose with personality.

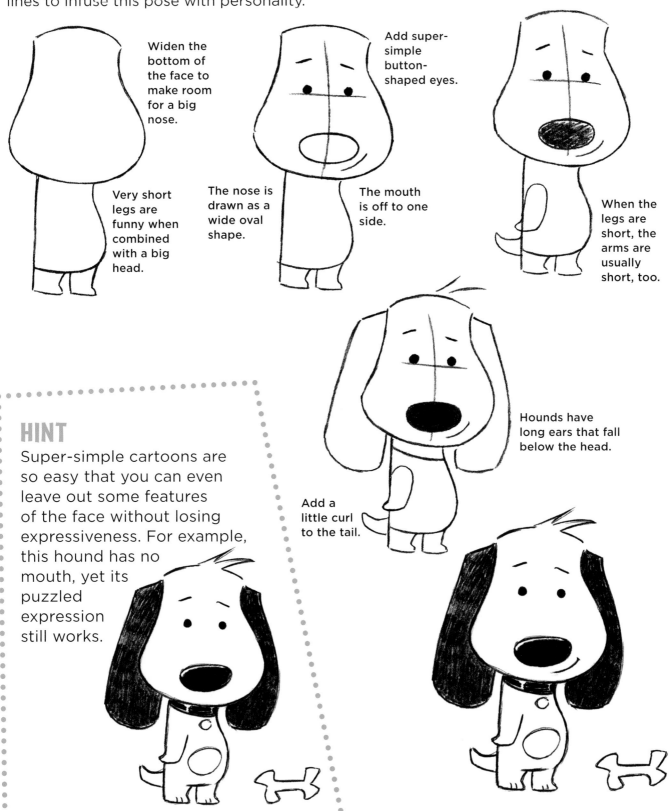

Widen the bottom of the face to make room for a big nose.

Very short legs are funny when combined with a big head.

Add super-simple button-shaped eyes.

The nose is drawn as a wide oval shape.

The mouth is off to one side.

When the legs are short, the arms are usually short, too.

Hounds have long ears that fall below the head.

Add a little curl to the tail.

HINT

Super-simple cartoons are so easy that you can even leave out some features of the face without losing expressiveness. For example, this hound has no mouth, yet its puzzled expression still works.

109

Super-Simple Pooch

Here's an alert dog, with his body coiled up at attention. He's either waiting for a signal from his owner to fetch something, or he's staring at his owner's sandwich. I'm guessing sandwich. Let's use exaggeration to infuse this pose with personality.

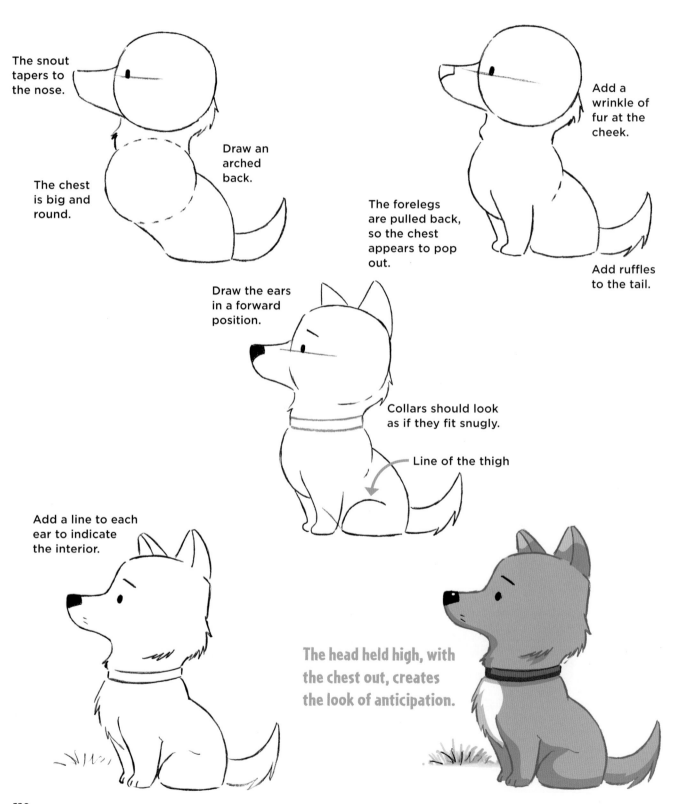

The snout tapers to the nose.

The chest is big and round.

Draw an arched back.

Add a wrinkle of fur at the cheek.

The forelegs are pulled back, so the chest appears to pop out.

Add ruffles to the tail.

Draw the ears in a forward position.

Collars should look as if they fit snugly.

Line of the thigh

Add a line to each ear to indicate the interior.

The head held high, with the chest out, creates the look of anticipation.

Super-Simple Hedgehog

Hedgehogs are a little weird looking, but cartoon fans love them. Their special appeal lies in the chubby outline of the body, which is reinforced by the fuzzy quills surrounding it. In addition, the arms are very small in contrast with its plump body.

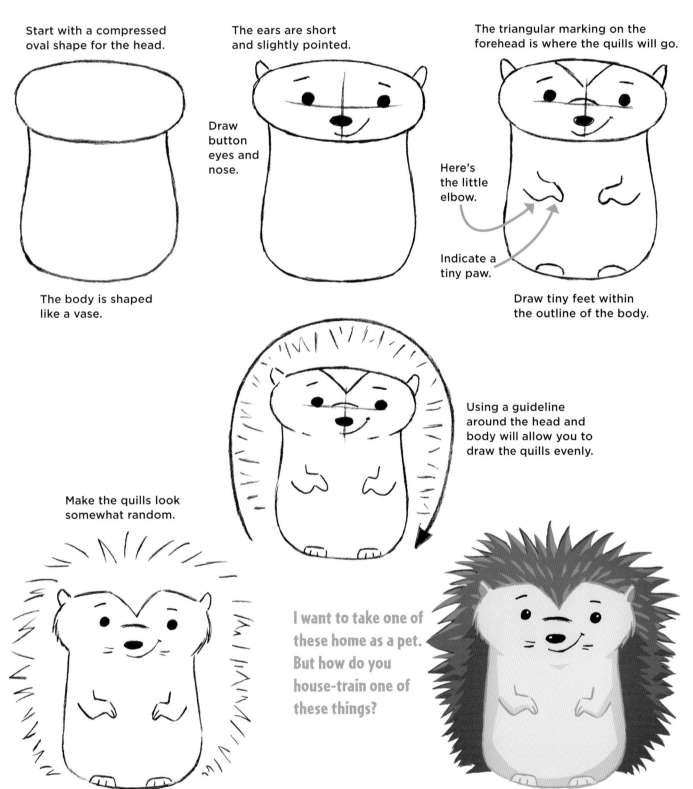

Start with a compressed oval shape for the head.

The ears are short and slightly pointed.

The triangular marking on the forehead is where the quills will go.

Draw button eyes and nose.

Here's the little elbow.

Indicate a tiny paw.

The body is shaped like a vase.

Draw tiny feet within the outline of the body.

Using a guideline around the head and body will allow you to draw the quills evenly.

Make the quills look somewhat random.

I want to take one of these home as a pet. But how do you house-train one of these things?

Super-Simple Antelope

One of the benefits of simplifying a cartoon animal is that it becomes easier to draw in an upright posture. Of course, the upright posture of a cartoon animal looks nothing like that of a real person's, but it creates a funny contrast.

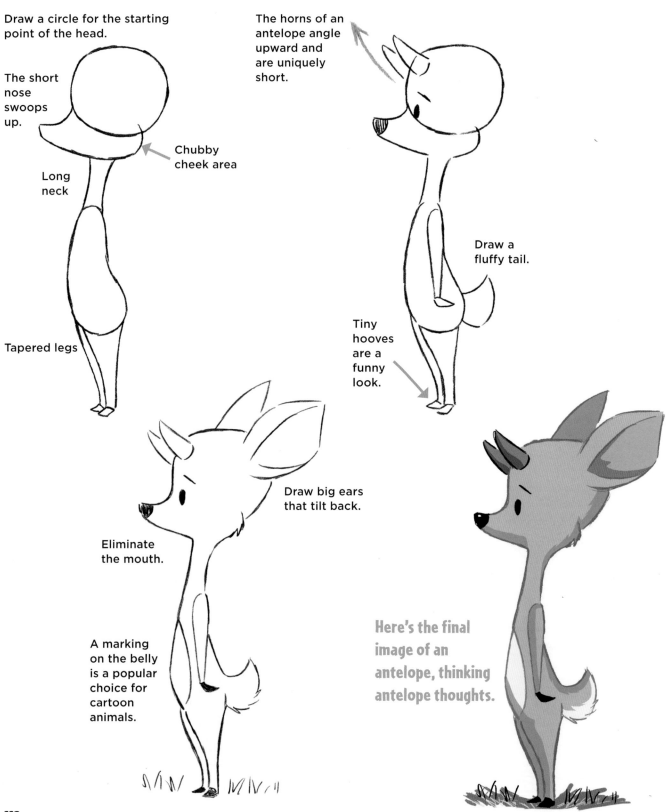

Draw a circle for the starting point of the head.

The short nose swoops up.

Long neck

Tapered legs

Chubby cheek area

The horns of an antelope angle upward and are uniquely short.

Draw a fluffy tail.

Tiny hooves are a funny look.

Eliminate the mouth.

Draw big ears that tilt back.

A marking on the belly is a popular choice for cartoon animals.

Here's the final image of an antelope, thinking antelope thoughts.

112

Super-Simple Gopher

My wife and I happen to have a gopher in our backyard. Either that, or it's an animal doing a pretty good imitation of one. Unlike the adorable, big nosed beaver, no one really knows what a gopher looks like. People may vaguely recall that they have buckteeth, but that's about all. This gives you the freedom to experiment with your character's design.

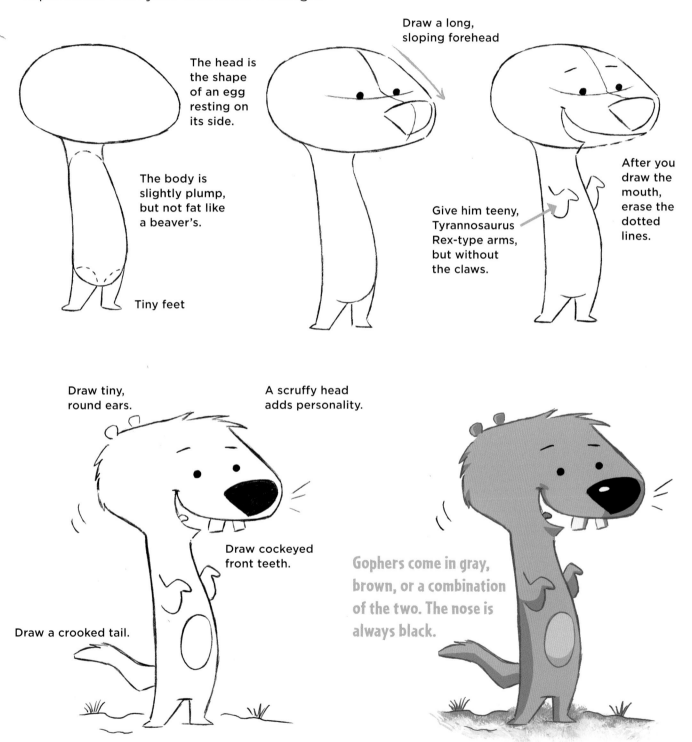

The head is the shape of an egg resting on its side.

The body is slightly plump, but not fat like a beaver's.

Tiny feet

Draw a long, sloping forehead

Give him teeny, Tyrannosaurus Rex-type arms, but without the claws.

After you draw the mouth, erase the dotted lines.

Draw tiny, round ears.

A scruffy head adds personality.

Draw cockeyed front teeth.

Draw a crooked tail.

Gophers come in gray, brown, or a combination of the two. The nose is always black.

Super-Simple Water Buffalo

A water buffalo is a powerful and intimidating animal, but we'll draw ours as a friendly guy. The neck can get a little tricky, therefore, we'll start by simplifying the head and body, so drawing the neck should fall into place easily.

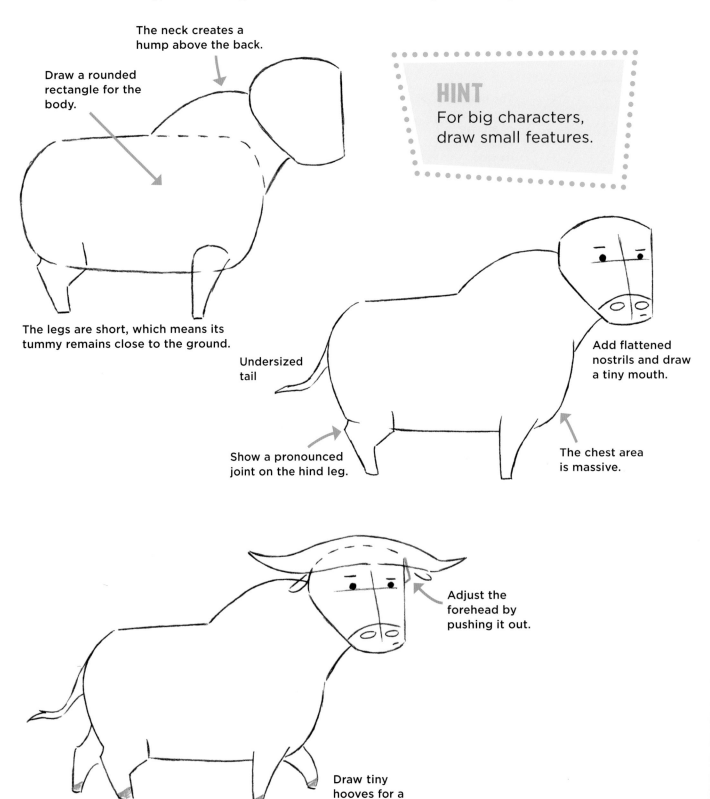

The neck creates a hump above the back.

Draw a rounded rectangle for the body.

HINT
For big characters, draw small features.

The legs are short, which means its tummy remains close to the ground.

Undersized tail

Show a pronounced joint on the hind leg.

Add flattened nostrils and draw a tiny mouth.

The chest area is massive.

Adjust the forehead by pushing it out.

Draw tiny hooves for a funny look.

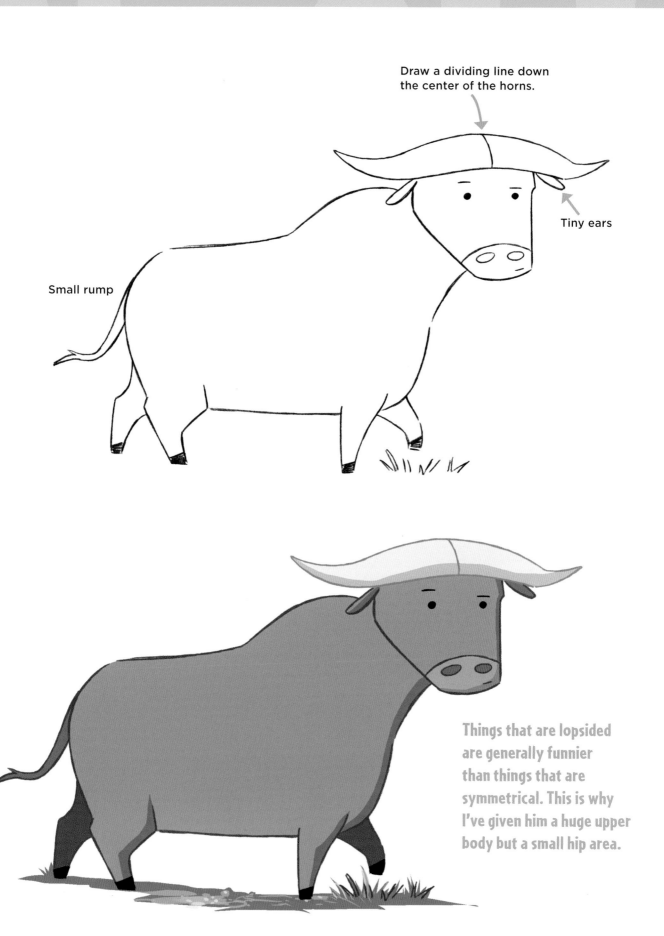

Draw a dividing line down the center of the horns.

Tiny ears

Small rump

Things that are lopsided are generally funnier than things that are symmetrical. This is why I've given him a huge upper body but a small hip area.

Super-Simple Lion

The giant, button eyes of this young lion character give him a huggable look. In fact, his eyes are bigger than his nose. His mouth looks small and harmless. However, he still gets a full-sized mane because it's his signature feature.

Draw an oversized head shape.

The neck is small.

The tail is drawn as a long, uneven line.

The body is shaped like a bean.

The smile rises in the middle, toward the nose. This is called a split lip.

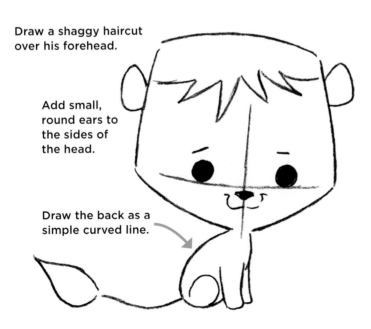

Draw a shaggy haircut over his forehead.

Add small, round ears to the sides of the head.

Draw the back as a simple curved line.

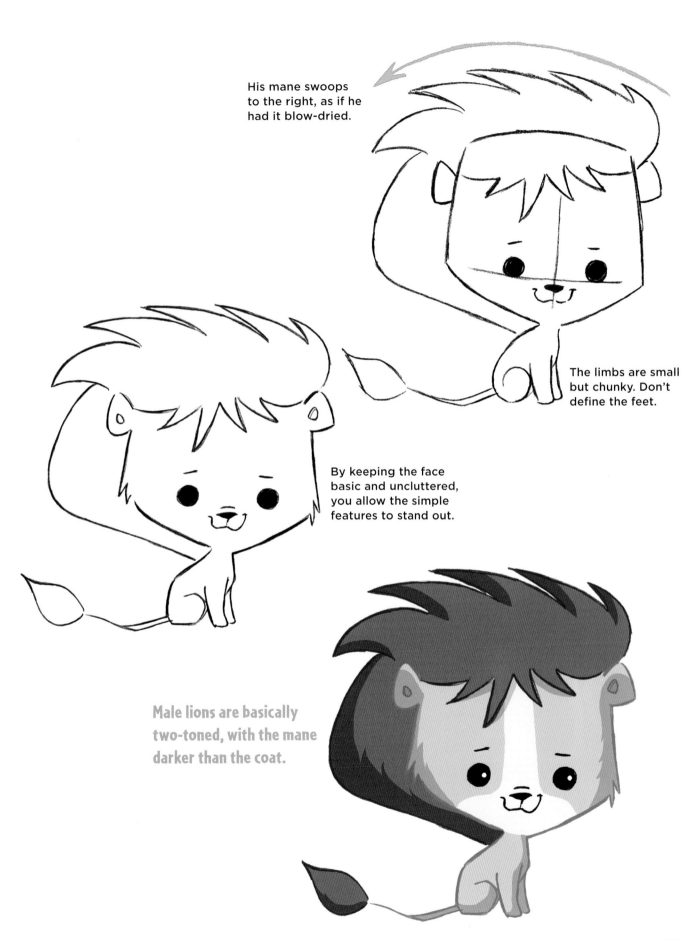

His mane swoops to the right, as if he had it blow-dried.

The limbs are small but chunky. Don't define the feet.

By keeping the face basic and uncluttered, you allow the simple features to stand out.

Male lions are basically two-toned, with the mane darker than the coat.

Super-Simple Bear

Bears come in all shapes and sizes. A popular type features super-exaggerated proportions: a large head and a tiny body. The long forehead and furry top are key to its character design. The side view is an appealing angle for young animals.

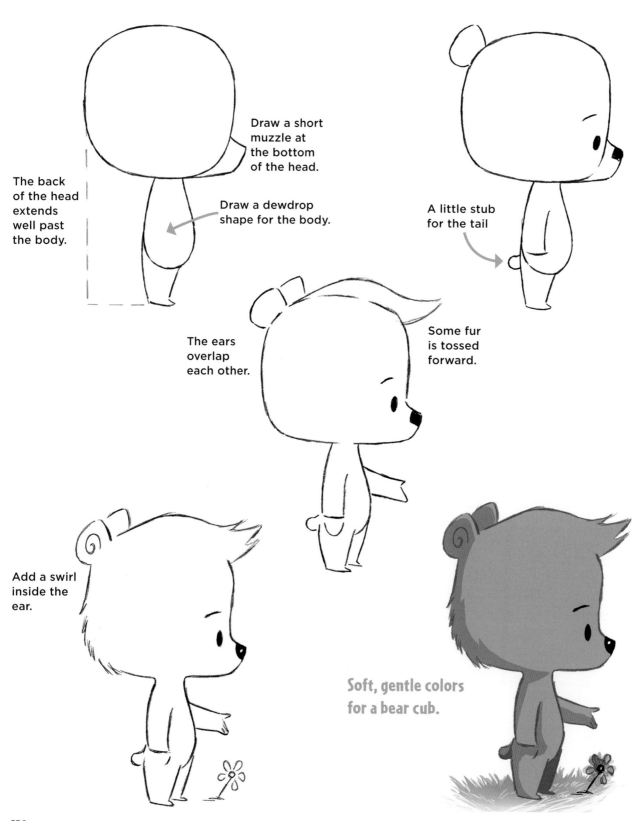

The back of the head extends well past the body.

Draw a short muzzle at the bottom of the head.

Draw a dewdrop shape for the body.

A little stub for the tail

The ears overlap each other.

Some fur is tossed forward.

Add a swirl inside the ear.

Soft, gentle colors for a bear cub.

Super-Simple Kitten

Kittens are made from two ingredients: fluff and fuzz. In fact, if all you drew was a ball of fuzziness with a collar, someone would guess that it was a kitten. But we will get even more specific than that. Believe it.

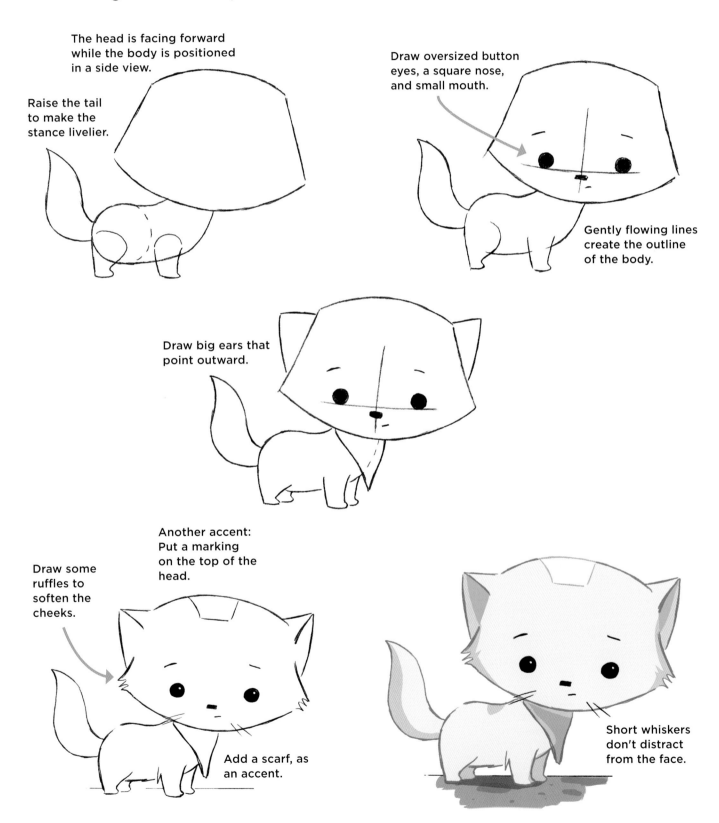

The head is facing forward while the body is positioned in a side view.

Raise the tail to make the stance livelier.

Draw oversized button eyes, a square nose, and small mouth.

Gently flowing lines create the outline of the body.

Draw big ears that point outward.

Another accent: Put a marking on the top of the head.

Draw some ruffles to soften the cheeks.

Add a scarf, as an accent.

Short whiskers don't distract from the face.

Super-Simple Chipmunk

Tiny characters are often drawn in confident and assertive poses. Such poses are used to offset their diminutive size. This results in a plucky attitude that's quite appealing. As we draw this simple character, keep two things in mind: the curve of the tummy and how the arms are posed.

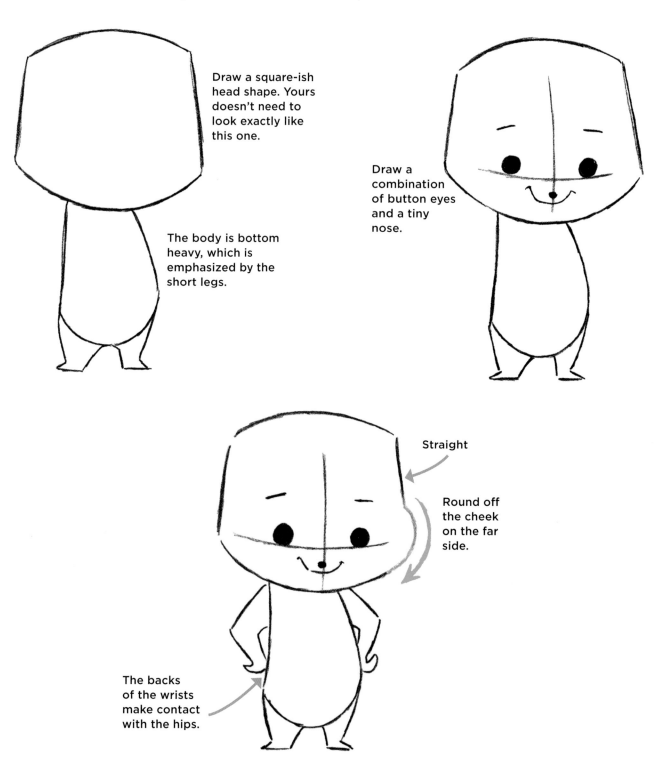

Draw a square-ish head shape. Yours doesn't need to look exactly like this one.

The body is bottom heavy, which is emphasized by the short legs.

Draw a combination of button eyes and a tiny nose.

Straight

Round off the cheek on the far side.

The backs of the wrists make contact with the hips.

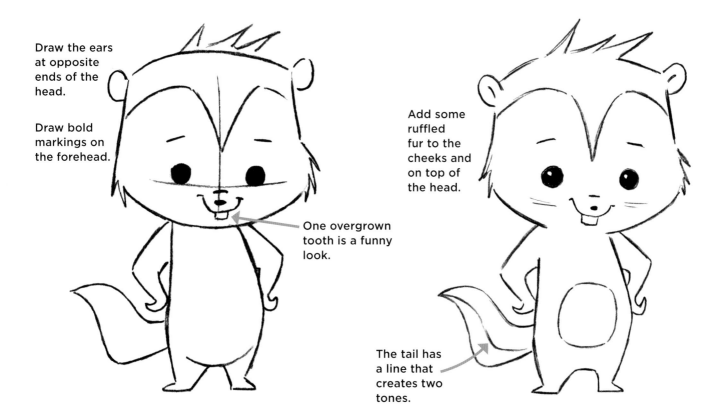

Draw the ears at opposite ends of the head.

Draw bold markings on the forehead.

One overgrown tooth is a funny look.

Add some ruffled fur to the cheeks and on top of the head.

The tail has a line that creates two tones.

SIMPLE VARIATION

In cartoons, the circular tummy patch is a popular feature. A common variation is to lengthen it so that it goes up to the chest.

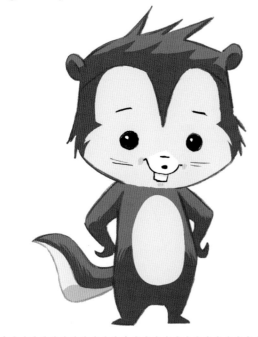

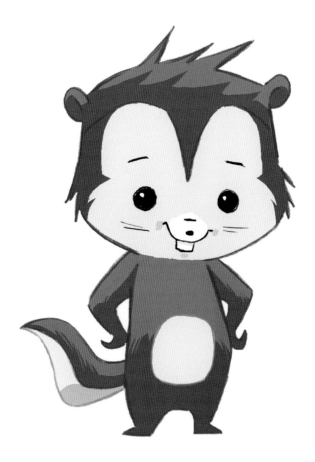

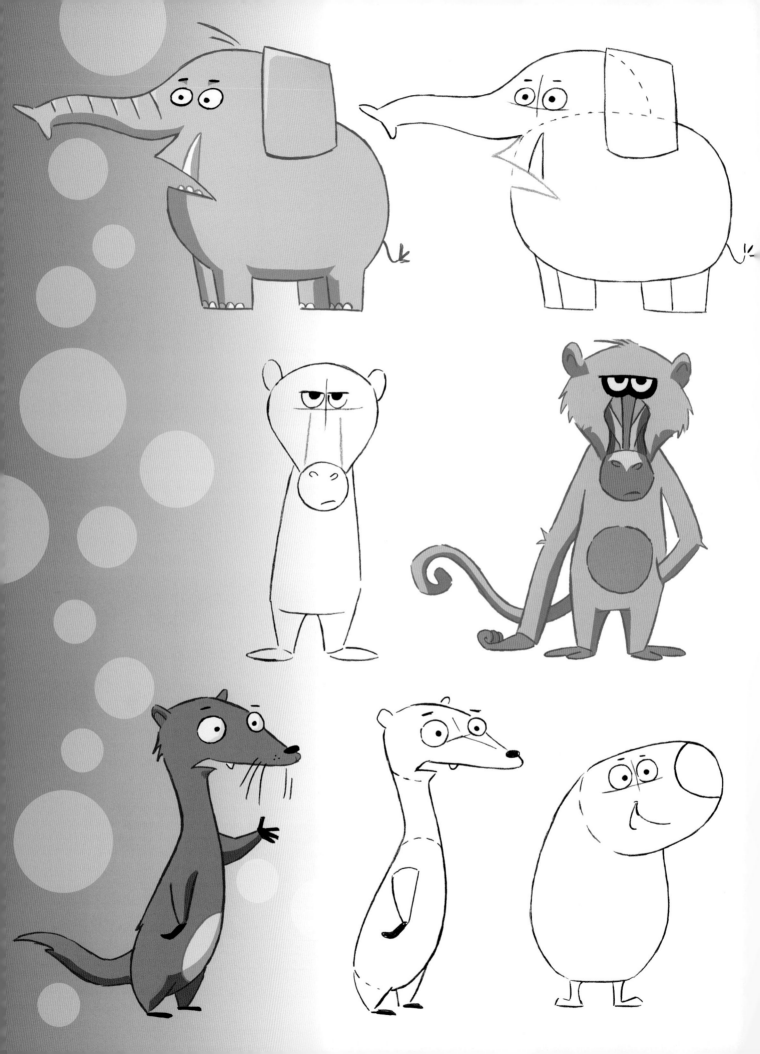

Unusual Animals

TV animation pushes the envelope in terms of character designs for animals. This enlivens the shows with novel and unexpected critters. These animals are famously odd looking and funny. In this last chapter, we'll cover many unique and curious species and learn how to exaggerate their weird physical traits, while at the same time making them engaging—and even charming.

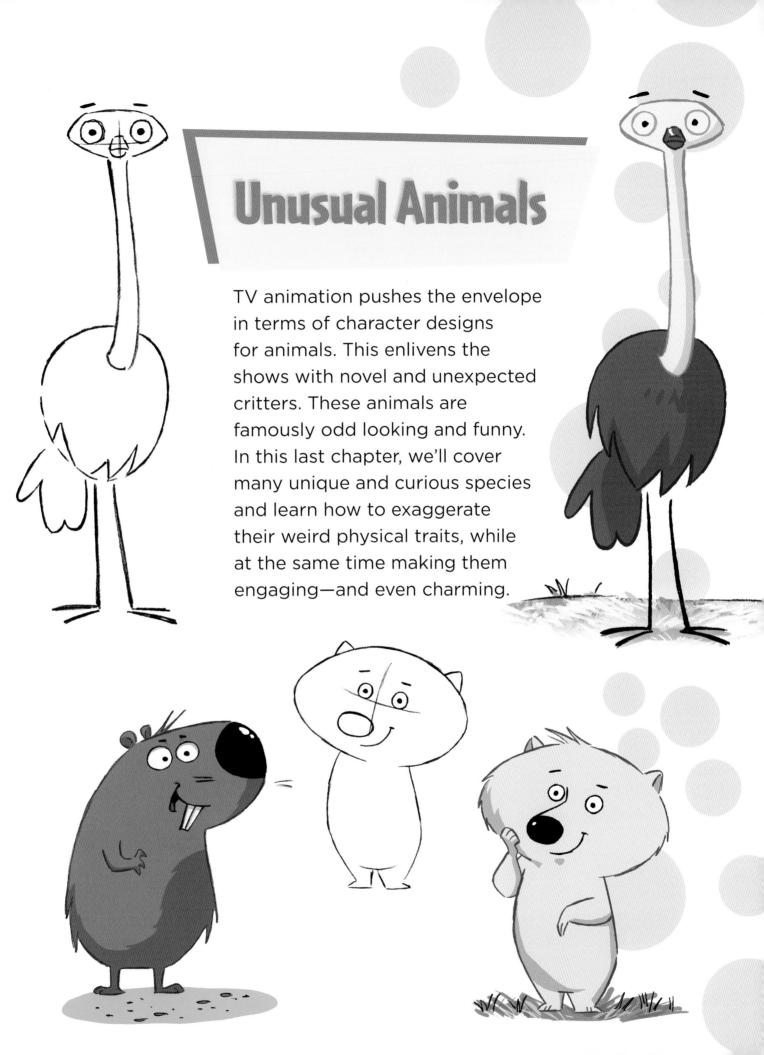

Weasel

Weasels are cast as sniveling characters that have a problem with honesty. Therefore, we'll need to create "dishonest" physical traits for him. It's best not to rely solely on facial expressions to convey personalities. We'll design him to look a little deceptive.

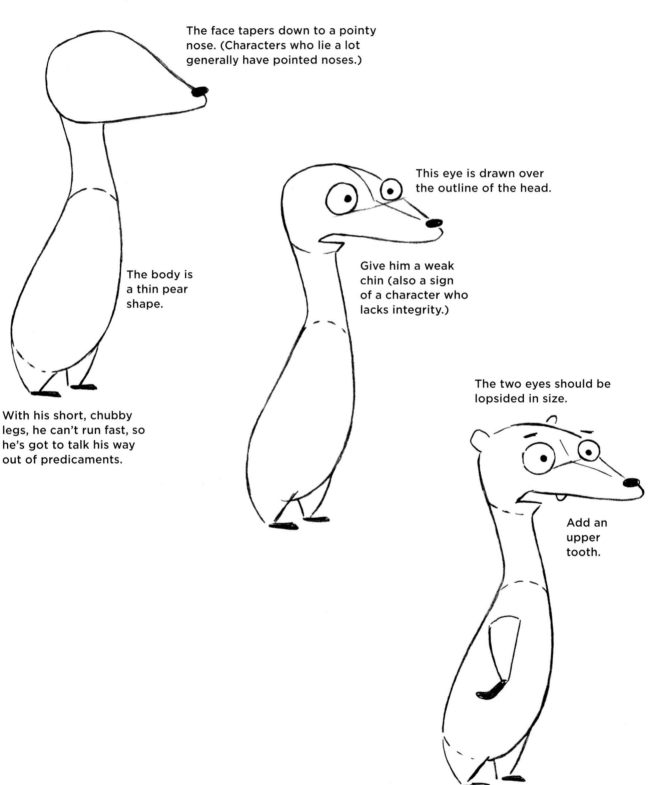

The face tapers down to a pointy nose. (Characters who lie a lot generally have pointed noses.)

The body is a thin pear shape.

With his short, chubby legs, he can't run fast, so he's got to talk his way out of predicaments.

This eye is drawn over the outline of the head.

Give him a weak chin (also a sign of a character who lacks integrity.)

The two eyes should be lopsided in size.

Add an upper tooth.

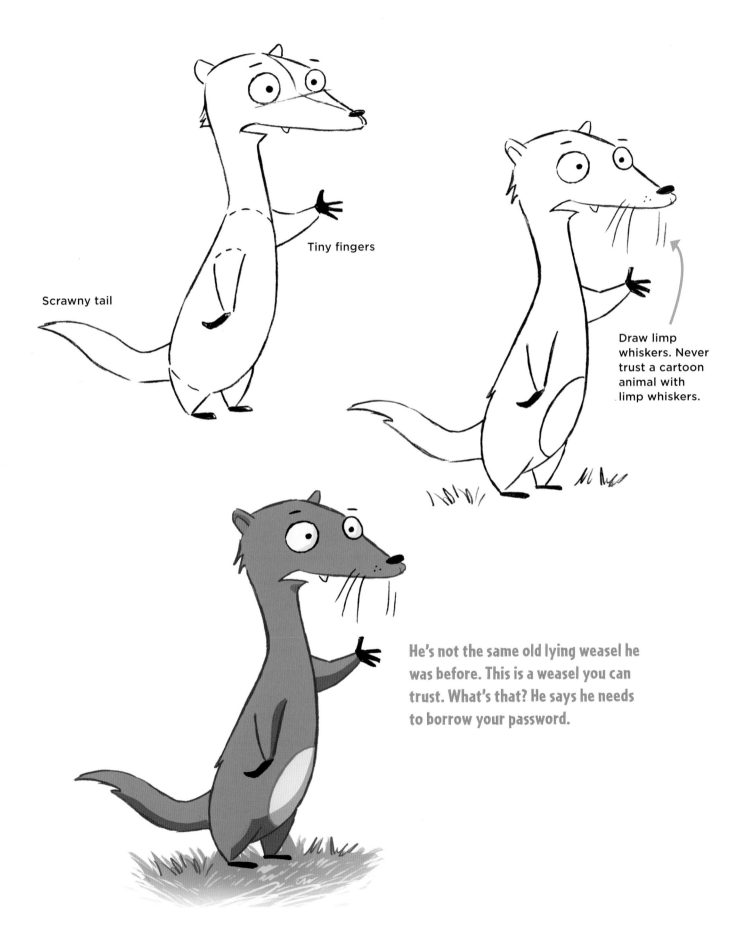

Tiny fingers

Scrawny tail

Draw limp whiskers. Never trust a cartoon animal with limp whiskers.

He's not the same old lying weasel he was before. This is a weasel you can trust. What's that? He says he needs to borrow your password.

Arctic Fox

The Arctic Fox is a rare animal that's completely white, super-fluffy, and small. The key to its appeal is its simple proportions: a large forehead, a slender snout, a long body, short legs, and an extra long tail. Let's start off by drawing both eyes on the same side of the head. That conveys broad humor to a cartoon-watching audience.

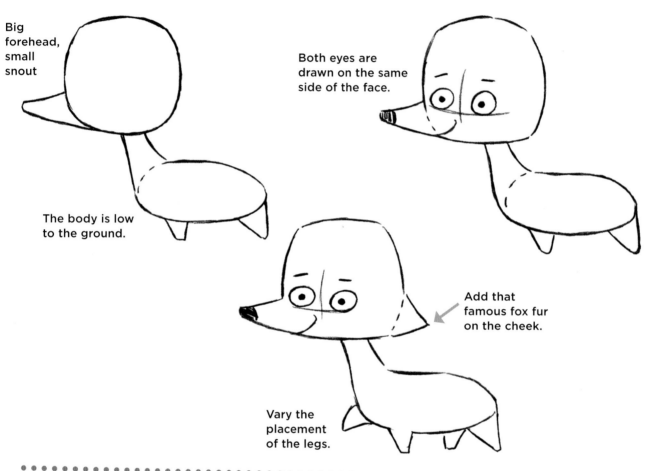

Big forehead, small snout

The body is low to the ground.

Both eyes are drawn on the same side of the face.

Add that famous fox fur on the cheek.

Vary the placement of the legs.

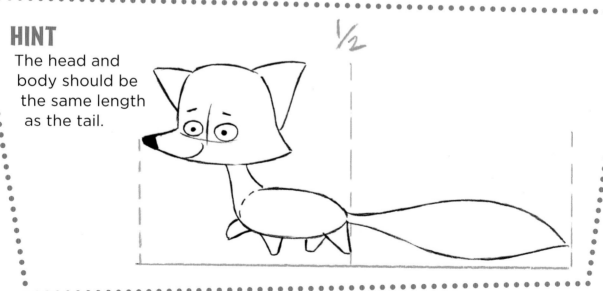

HINT
The head and body should be the same length as the tail.

½

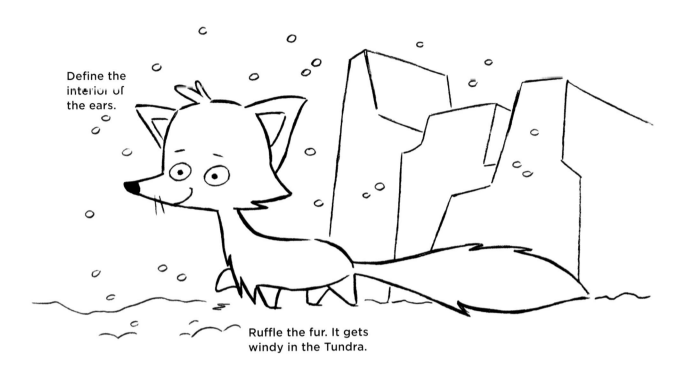

Define the interior of the ears.

Ruffle the fur. It gets windy in the Tundra.

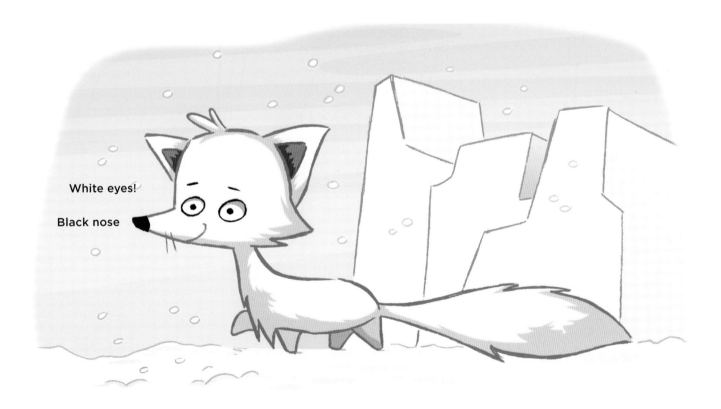

White eyes!

Black nose

This scene has two contrasting elements that give it variety and make it appealing. First, we have the soft-looking coat of the furry fox. That's contrasted with the geometric lines of the glaciers.

Vicuña

You're more likely to have come across a vicuña as a vocabulary word than you are to see one in person. This rare species is related to the camel and the llama. The random look of this animal is its appeal. Cartooning is often about drawing something awkward, but in a humorous way.

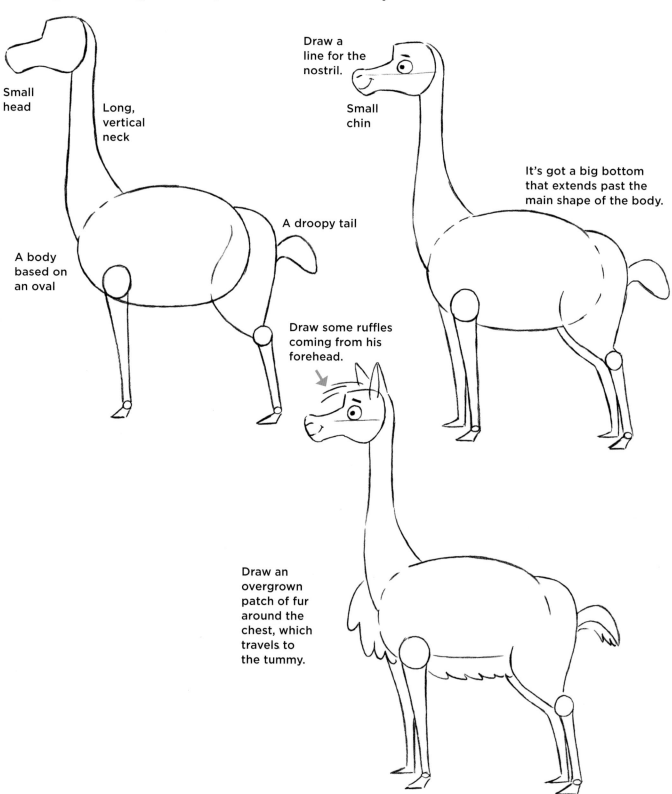

Small head

Long, vertical neck

A body based on an oval

A droopy tail

Draw a line for the nostril.

Small chin

It's got a big bottom that extends past the main shape of the body.

Draw some ruffles coming from his forehead.

Draw an overgrown patch of fur around the chest, which travels to the tummy.

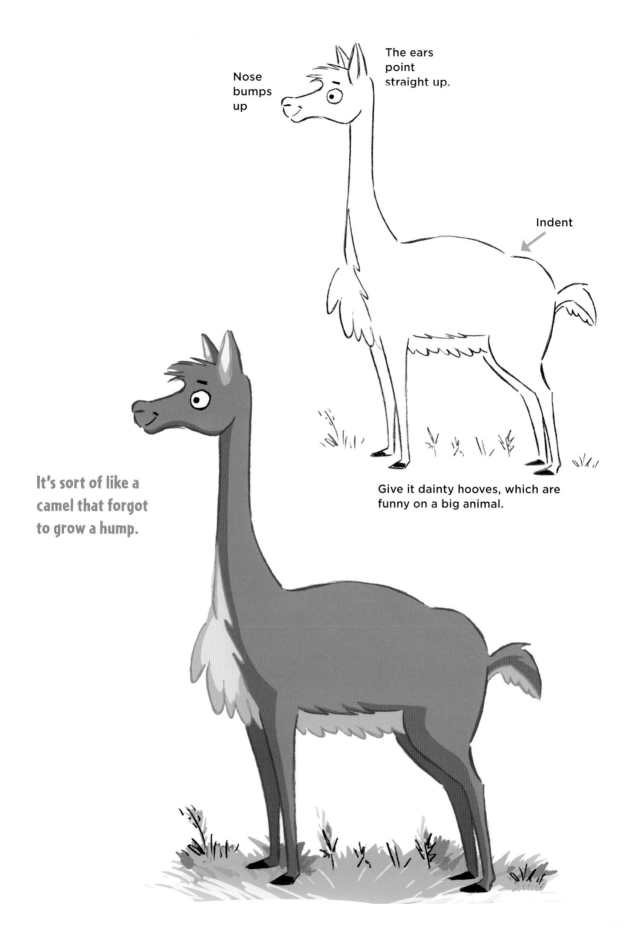

Nose bumps up

The ears point straight up.

Indent

Give it dainty hooves, which are funny on a big animal.

It's sort of like a camel that forgot to grow a hump.

Armadillo

When deciding how to draw the armadillo, I like to take my cue from its overwrought armor. It looks like it's ready for the next asteroid attack. Two obvious choices for its personality are confident and nervous. For this drawing, I picked nervous.

He's got interesting proportions—a long face and a squat body.

Small legs mean that a career as a basketball player is not in his future.

Draw two slits for nostrils.

The snout extends way past the lower jaw.

Underbite

Draw a long line for the back.

Give him small, flat feet.

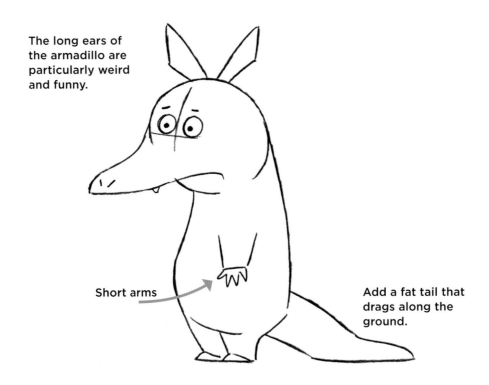

The long ears of the armadillo are particularly weird and funny.

Short arms

Add a fat tail that drags along the ground.

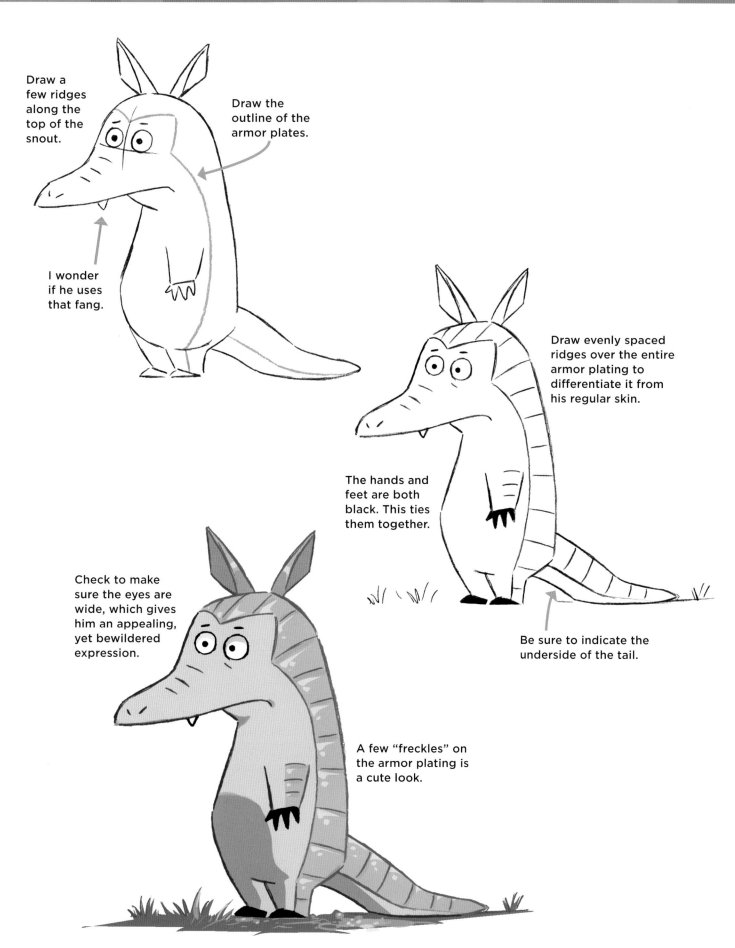

Draw a few ridges along the top of the snout.

Draw the outline of the armor plates.

I wonder if he uses that fang.

Draw evenly spaced ridges over the entire armor plating to differentiate it from his regular skin.

The hands and feet are both black. This ties them together.

Be sure to indicate the underside of the tail.

Check to make sure the eyes are wide, which gives him an appealing, yet bewildered expression.

A few "freckles" on the armor plating is a cute look.

Capybara

The capybara is quite an unusual animal. This 200-pound super-rodent looks like the product of an evil scientist's experiment gone wrong. But look a little deeper and you'll see a sociable animal, which is actually related to the guinea pig. Taking our cue from the real animal, I've purposefully drawn the capybara as chubby, cheerful, and awkwardly constructed.

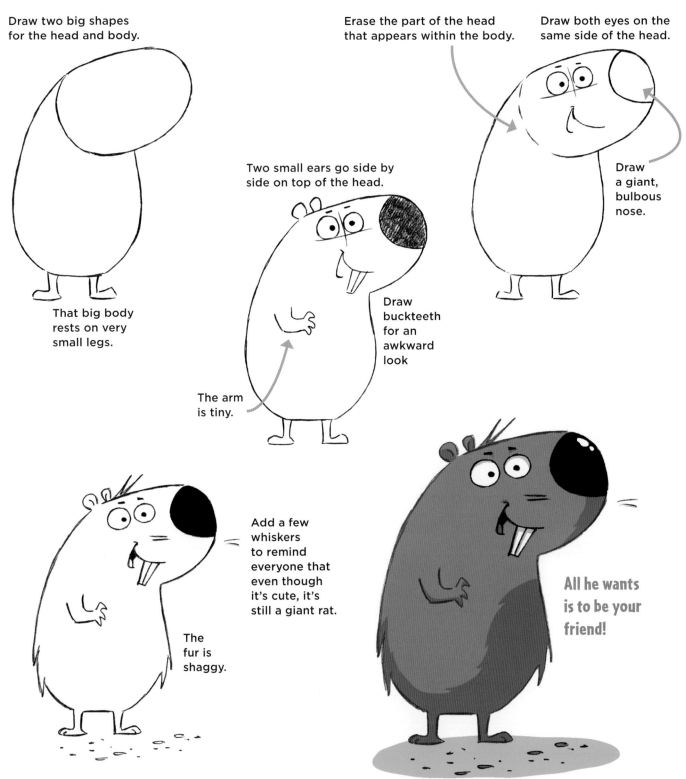

Draw two big shapes for the head and body.

That big body rests on very small legs.

Two small ears go side by side on top of the head.

The arm is tiny.

Draw buckteeth for an awkward look

Erase the part of the head that appears within the body.

Draw both eyes on the same side of the head.

Draw a giant, bulbous nose.

The fur is shaggy.

Add a few whiskers to remind everyone that even though it's cute, it's still a giant rat.

All he wants is to be your friend!

Tapir

A tapir is a rare animal with a face that is perfect for funny expressions. It's constructed like a combination of an elephant and a pig. It looks like a first draft of an animal that somehow passed inspection, and now we have tapirs. We'll take our cue from the inward-curling nose and use it to create a sneaky expression.

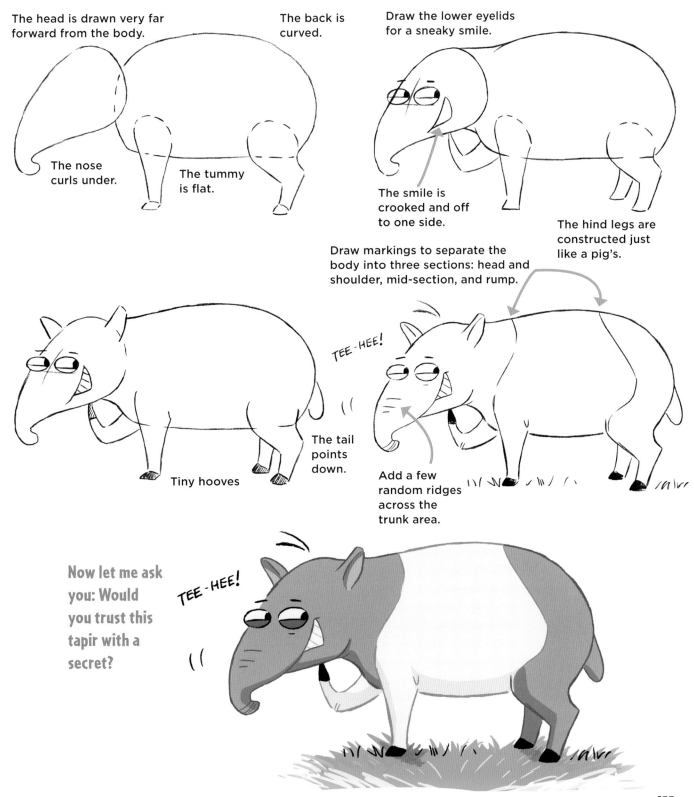

The head is drawn very far forward from the body.

The back is curved.

The nose curls under.

The tummy is flat.

Draw the lower eyelids for a sneaky smile.

The smile is crooked and off to one side.

The hind legs are constructed just like a pig's.

Draw markings to separate the body into three sections: head and shoulder, mid-section, and rump.

TEE-HEE!

The tail points down.

Tiny hooves

Add a few random ridges across the trunk area.

Now let me ask you: Would you trust this tapir with a secret?

TEE-HEE!

133

Longhorn

Unwieldy proportions make this animal unusual and a good choice for a cartoon character. But the horns are not the only odd proportion. Just look at those short, funny arms and legs. The widely spaced eyes are yet another variation on the theme of odd proportions. Taking our cue from the wide proportions, we'll build up this character to be broad and strong.

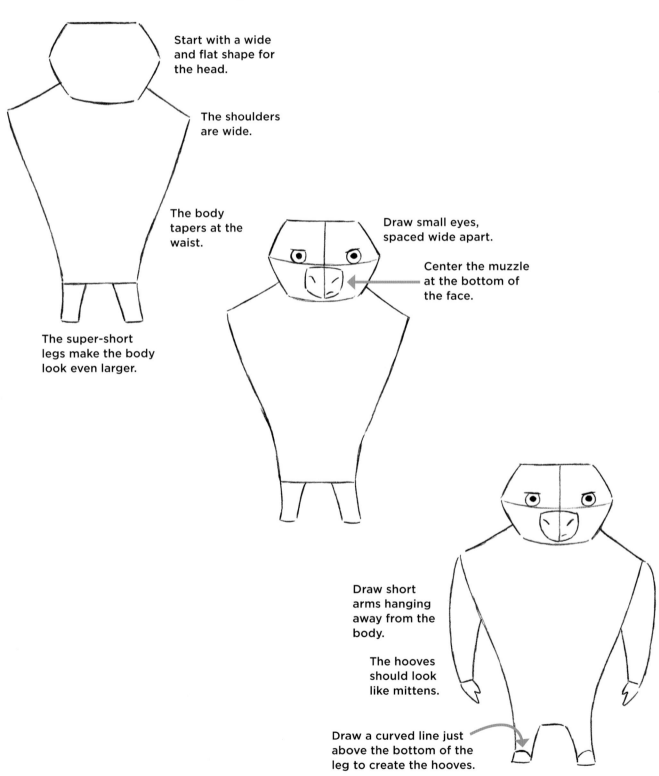

Start with a wide and flat shape for the head.

The shoulders are wide.

The body tapers at the waist.

The super-short legs make the body look even larger.

Draw small eyes, spaced wide apart.

Center the muzzle at the bottom of the face.

Draw short arms hanging away from the body.

The hooves should look like mittens.

Draw a curved line just above the bottom of the leg to create the hooves.

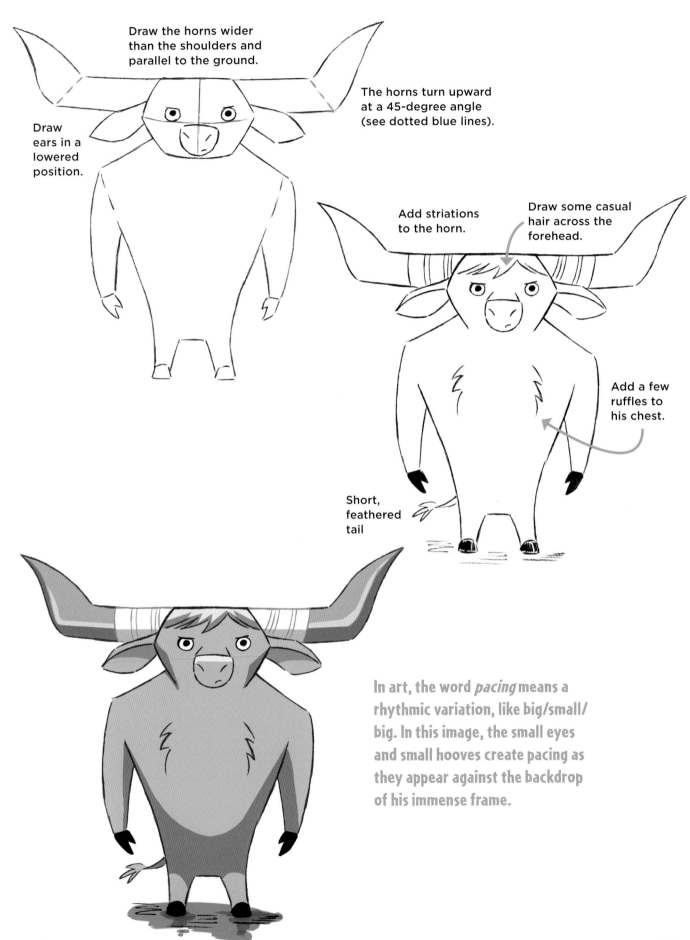

Draw the horns wider than the shoulders and parallel to the ground.

The horns turn upward at a 45-degree angle (see dotted blue lines).

Draw ears in a lowered position.

Add striations to the horn.

Draw some casual hair across the forehead.

Add a few ruffles to his chest.

Short, feathered tail

In art, the word *pacing* means a rhythmic variation, like big/small/ big. In this image, the small eyes and small hooves create pacing as they appear against the backdrop of his immense frame.

135

Mandrill

No one wants to pet a mandrill. It's weird looking. Its face looks like a kid colored it with gumdrops. Yet at the same time these creatures are oddly engaging. They look smart, funny, and cartoonish. They're a good offbeat addition to any animated show.

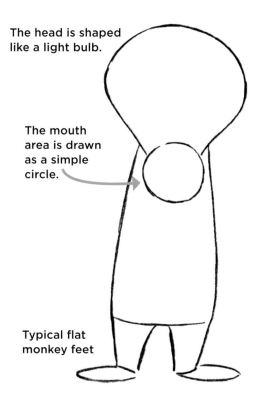

The head is shaped like a light bulb.

The mouth area is drawn as a simple circle.

Typical flat monkey feet

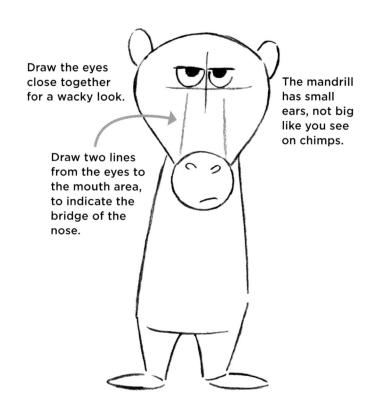

Draw the eyes close together for a wacky look.

Draw two lines from the eyes to the mouth area, to indicate the bridge of the nose.

The mandrill has small ears, not big like you see on chimps.

DRAWING THE MANDRILL SNOUT STEP BY STEP

Step 1 Create a thin alley from the eyes to the mouth section.

Step 2 Bracket the alley with a curved line on both sides. Make sure that the lines mirror each other.

Step 3 Draw a diagonal strip on both sides.

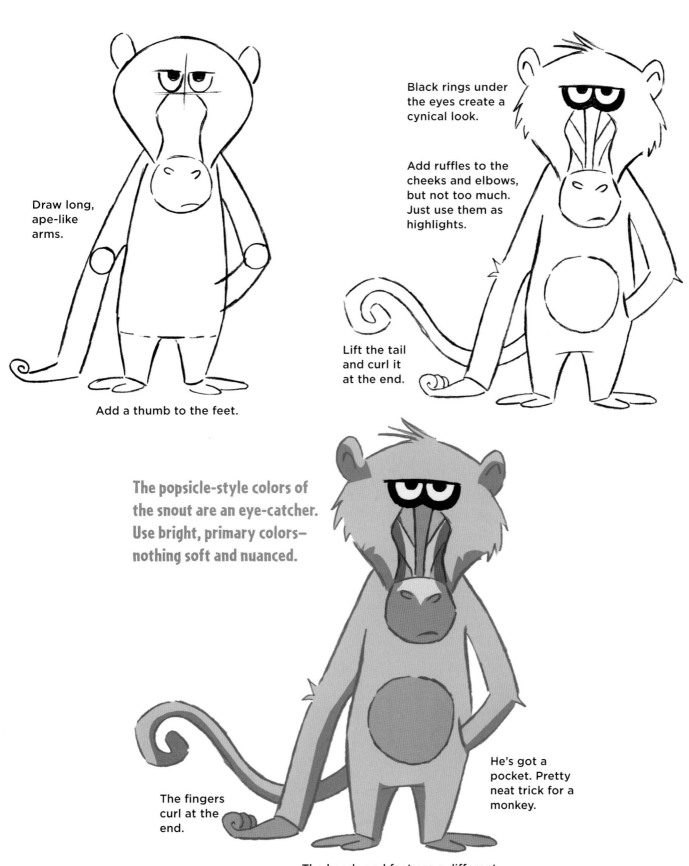

Draw long, ape-like arms.

Add a thumb to the feet.

Black rings under the eyes create a cynical look.

Add ruffles to the cheeks and elbows, but not too much. Just use them as highlights.

Lift the tail and curl it at the end.

The popsicle-style colors of the snout are an eye-catcher. Use bright, primary colors—nothing soft and nuanced.

The fingers curl at the end.

He's got a pocket. Pretty neat trick for a monkey.

The hands and feet are a different color than the rest of its furry body.

Emu

An emu is an odd looking bird. Instead of having a feathery coat, it looks hairy, sort of like a hand-me-down suit. But the awkward appearance gives it a weird charm. We're going to "cartoonize" the legs so that they have nothing in common with actual bird legs. Why do we do that? It's funnier!

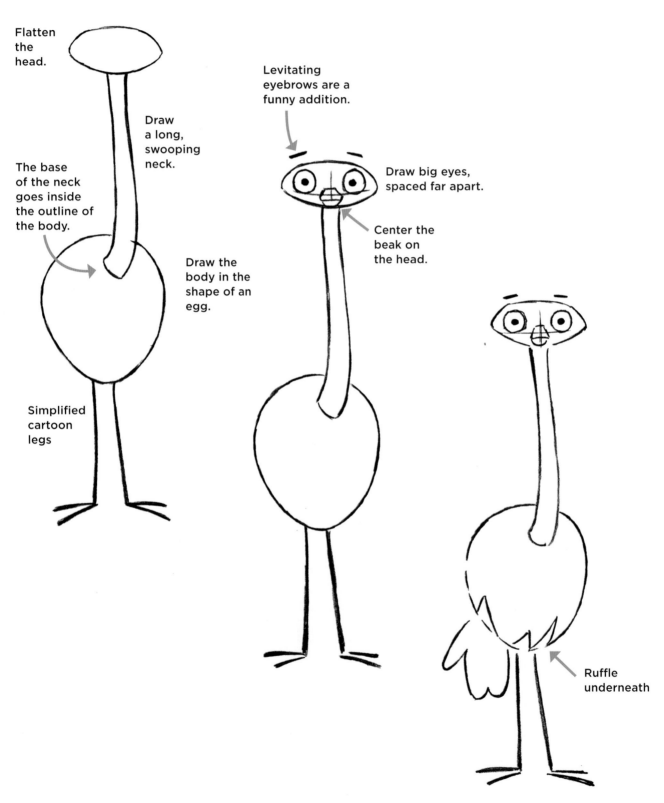

Flatten the head.

The base of the neck goes inside the outline of the body.

Draw a long, swooping neck.

Simplified cartoon legs

Draw the body in the shape of an egg.

Levitating eyebrows are a funny addition.

Draw big eyes, spaced far apart.

Center the beak on the head.

Ruffle underneath

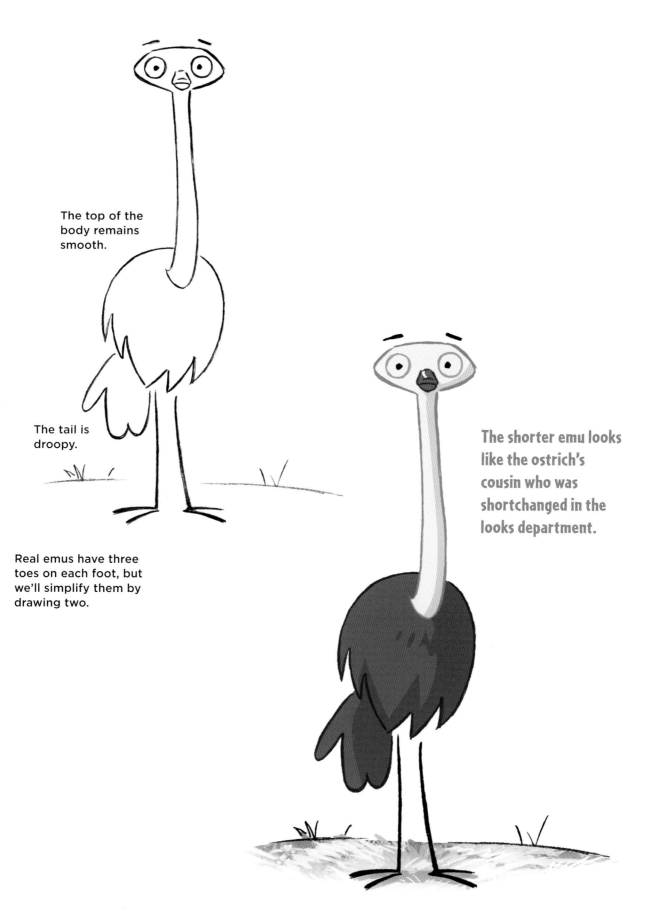

The top of the body remains smooth.

The tail is droopy.

Real emus have three toes on each foot, but we'll simplify them by drawing two.

The shorter emu looks like the ostrich's cousin who was shortchanged in the looks department.

Wombat

A wombat is like a sock puppet with claws. It's appealing in a weird way. I'm convinced that part of its appeal is its funny sounding name. The design is basic: one round shape on top of another round shape. With this character, don't get too detailed. Keep everything simple.

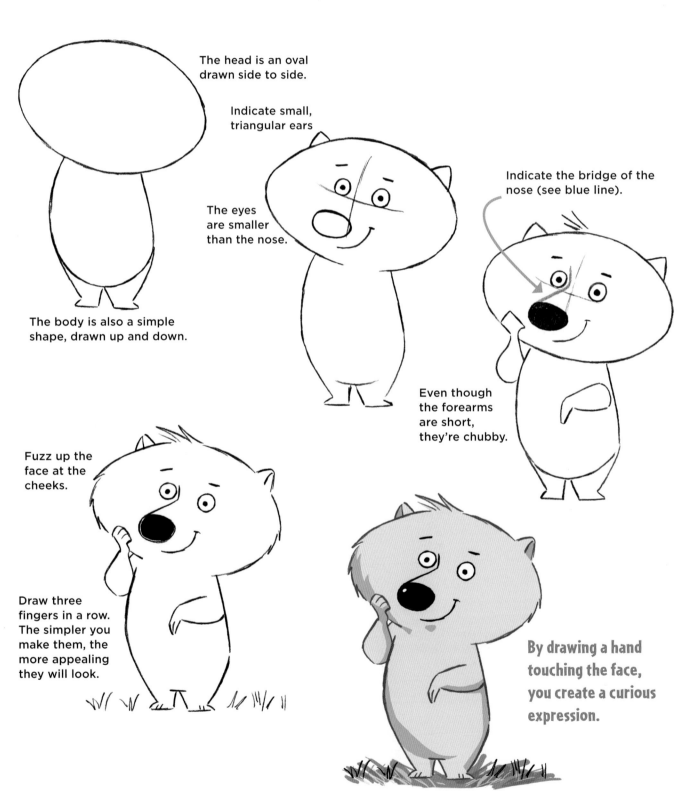

The head is an oval drawn side to side.

Indicate small, triangular ears

The eyes are smaller than the nose.

The body is also a simple shape, drawn up and down.

Indicate the bridge of the nose (see blue line).

Even though the forearms are short, they're chubby.

Fuzz up the face at the cheeks.

Draw three fingers in a row. The simpler you make them, the more appealing they will look.

By drawing a hand touching the face, you create a curious expression.

Turning Normal Animals into Unusual Ones

Unusual animals bring fun and novelty to animated TV shows and movies, but you don't need to travel to the remote forests of the Amazon to find such unusual creatures. You can create your own based on traditional animals. The trick is in the initial construction. By solving common problems in a creative way, such as how to draw an elephant's trunk, you can invent very unusual animals.

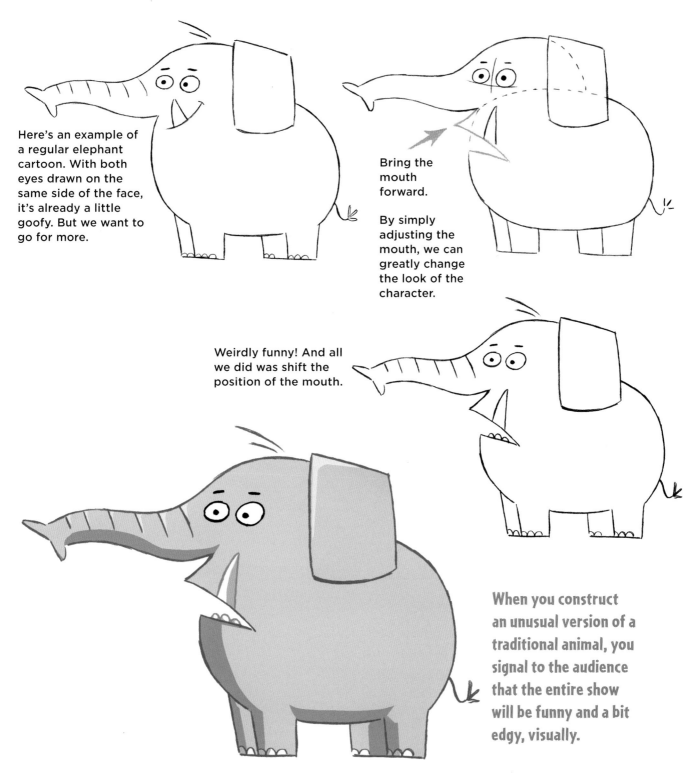

Here's an example of a regular elephant cartoon. With both eyes drawn on the same side of the face, it's already a little goofy. But we want to go for more.

Bring the mouth forward.

By simply adjusting the mouth, we can greatly change the look of the character.

Weirdly funny! And all we did was shift the position of the mouth.

When you construct an unusual version of a traditional animal, you signal to the audience that the entire show will be funny and a bit edgy, visually.

INDEX

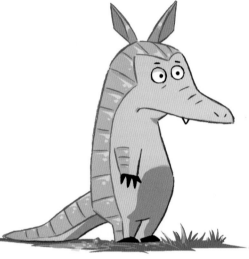
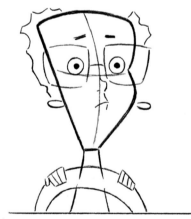

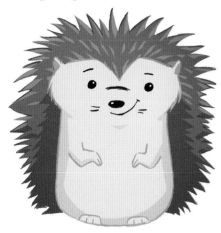
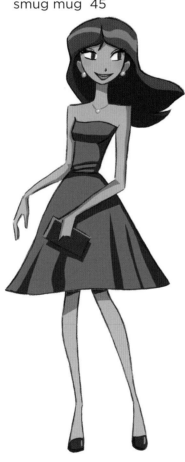
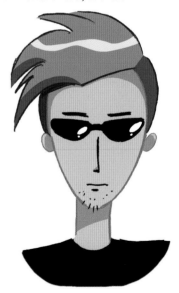

A NOTE FROM THE AUTHOR

I hope this book has helped you to get started in drawing cartoons. For some people, it becomes a lifelong passion or even a career. Don't worry if your characters don't look exactly like mine. Maybe yours have bigger eyes, or different proportions. All that means is that you have your own way of perceiving things. If that weren't true, we'd all draw the same way. And what fun would that be? Embrace your point of view. This is how styles emerge. Follow your pencil wherever it takes you, and enjoy the journey!